To frien♡

Merry Christmas

Love Debbie &
Russ

2002

Mark Hampton

THE ART OF FRIENDSHIP

Mark Hampton

THE ART OF FRIENDSHIP

by

DUANE HAMPTON

Cliff Street Books

An Imprint of HarperCollinsPublishers

HarperCollins books may be purchased for educational, business, or sales promotional use. For information please write: Special Markets Department, HarperCollins Publishers, Inc., 10 East 53rd Street, New York, NY 10022.

FIRST EDITION

Designed by Robin Arzt
Project Director: Joseph Montebello

Hampton, Duane.
 Mark Hampton: the art of friendship / Duane Hampton.—1st ed.
 p. cm.
 ISBN 0-06-018512-0
 1. Hampton, Mark—Exhibitions. I. Title: Art of friendship. II. Hampton, Mark. III. Title.

ND1839.H362 A4 2001
759.13—dc21 2001028759

02 03 04 05 ❖/IM 10 9 8 7 6 5 4 3

For Kate and Alexa
who have provided
joy and inspiration
for both of their parents

INTRODUCTION

In June of 1980, as a surprise for his fortieth birthday, an exhibition of Mark's sketches, drawings, and watercolors was held at the Acquavella Gallery in New York City. It was more than just a surprise for Mark; the show was an eye-opener for many who knew him only as an interior decorator.

Comprised of more than 350 works, the exhibition ranged from sketches in his grade-school notebooks to birthday cards painted for friends and family. It included a watercolor of a house (that won Best in Show in a statewide art competition in Indiana when he was twelve years old), a pair of corduroy pants painted with mementoes of fifties' school days, and an *Alice in Wonderland* screen painted for our niece's nursery. Paper Christmas ornaments painted in jewel tones hung on a tall, out-of-season spruce in the foyer of the gallery, while Easter eggs, hand-blown and intricately decorated for parties we had given in our graduate school years, were sheltered in a vitrine.

The show was organized as a fund-raiser for a school for autistic children, as a novel way to collect money for a good cause, and because I knew very

well that Mark would otherwise be embarrassed by such an elaborate display of his lifelong artistic endeavors. Mark never boasted about his talent. He often said, "Pretentiousness is fatal to decoration," and I know he felt arrogance to be the greatest of character flaws. Of course, artists—the good ones, at least—always seem to find fault with their creations.

Two subsequent, posthumous exhibitions of Mark's artwork led to the publication of this book. One focused on his interior and architectural watercolors and was the centerpiece of the Winter Antiques Show in New York in January of 1999. The second displayed 511 of his works on paper. There were illustrated letters, valentines, cards painted for birthdays, anniversaries, and other special occasions—"that he seemed to know about in advance for maybe two or three hundred people," as a close friend remarked—as well as still lifes and portraits of rooms, gardens, buildings, animals, and people. Held at the New York School of Interior Design, the exhibition ran from April 7 to May 29, 1999, attracting more than five thousand visitors and receiving a review in the *New York Times* Gallery Guide that would have delighted the artist. Comments from gallery-goers included: "How did he ever get any decorating done?" "Did he ever sleep?" "I had no idea he was so funny!" "This all makes me wish I had gotten to know him better." "I feel I actually knew the man, although I never met him." Or, my personal favorite, "Wow!" The most touching observation about the show was made by the security guard. At the end of his two-month stint, he said that he would really miss the pictures and the public's reactions to them.

The catalog for the birthday exhibition in 1980 was written by our great friend—lawyer, politician, and bibliophile Carter Burden. He cited 1940 as the year of Dunkirk, of Nazi troops marching down the Champs Elysées, and the McDonald brothers' sale of the first Big Mac. What Carter did not include about that year, since many of us had not yet been made aware of it, was that 1940 was the twentieth century's year of the Golden Dragon, a phenomenon occurring only once every sixty years in the Chinese zodiac, assuring those born under its aegis extraordinary blessings of talent, charm, luck, and success.

Mark was born that auspicious year in Plainfield, Indiana, a small town settled by the Society of Friends, or Quakers. He was raised a Friend, and although organized religion became less important to him later in life, being a friend—in its more universal sense—became the heart of his existence, an expression of his soul.

If "work and love are all that matters," as Freud said, then Mark's life was exemplary; and his family certainly must be given credit for his priorities. His father had artistic talent as well—we have a picture of a horse he painted on a barn door that one of his sisters cut out and saved for him when the door was replaced. Due to the Depression, Mark Sr. had to leave college and his beloved family farm in Richmond, Indiana, and take a job as an undertaker in a small town west of Indianapolis. He farmed in Plainfield as well and was too busy to travel much farther than across the state to visit his eight brothers and sisters. Mark's mother, Alice, originally from Indianapolis, became deeply involved in her new community and church while keeping a sharp eye on fashion and style. A leggy beauty with great charm, she was a terrific cook,

seamstress, and bridge player, who helped to raise two outgoing and energetic children. His sister, Rachel, raised her own children and then became the director of Northwestern University's graduate program in communication. A family fascination with houses and antiques was inherited by both children.

The hard lessons of the Depression, transmitted to him through his parents, were undoubtedly responsible for Mark's work ethic. A colleague once said that he was the only person he'd ever known who seemed to use 100 percent of his potential, working exhaustingly long hours and leaving no detail unattended. His father's admonition, "Don't ever tell me you're bored," certainly left its stamp on his son. He told me if even the faintest sigh or suggestion of boredom was detected by parental radar, he was made to go wash the car or clean out the basement or some other useful—if unwelcome—chore. And he always had a summer job in the months before the obligatory baling of hay on the farm in the dusty heat of August. In all the years I knew him, Mark successfully kept boredom at bay—except maybe in torts class or at a football game.

Perhaps this early training was what made the adult Mark excel at "multitasking" long before the word was coined. He could paint a watercolor while talking on the phone to the upholsterer, shushing the girls at the kitchen table, and keeping an eye on his famous tuna melts in the toaster oven.

Part of Mark's artistic talent was, of course, innate. He was born with an "eye" and a photographic memory. Mrs. Herman Ramsey, who taught art for forty years in his hometown and introduced him to watercolor technique, said of her pupil, "Mark's ability was as natural as breathing. Comparing him to

other students would be like comparing the Matterhorn to surrounding mountains." His skill in drawing and painting, in tandem with his imagination, was encouraged and applauded throughout his childhood, which helped him endure what one of his closest friends, publisher Robert Macdonald, described as "that most fatal and ostracizing of American flaws…youth as a nonathlete." And this in the basketball-crazed state of Indiana! His aunt Rachel's collection of *House and Home* magazines and Mark's discovery of the wonders of Williamsburg and Winterthur led to his first foray into decorating: finding and refinishing antique shutters for his bedroom window—at age eleven. Endless hours were spent stretched out on the living room rug sketching while listening to radio programs such as *Amos and Andy*, *Fibber McGee and Molly*, *Inner Sanctum*, and *Grand Central Station*. For the rest of his life he could imitate perfectly those radio sound effects of trains rushing toward Grand Central under Park Avenue. I'm sure he fantasized even then about living in New York one day, since he was a self-proclaimed "major daydreamer."

In high school Mark came into his own. Witty doodles of animals, cars (he was always obsessed by beautiful cars and knew who had designed them and when—the famous 1941 Lincoln Continental was his favorite), rooms and houses bordered his classroom notes, along with wicked caricatures of teachers and endless sketches of glamour girls: some dressed beautifully, some not at all. This caught everyone's attention. He was in great demand by the yearbook staff for illustrations, by the drama department for scenery painting, and by his friends for a Plainfield High custom: painting corduroy pants for the boys and skirts for the girls (remember, these were the fifties) with personal-

ized scenes of their lives and interests. Contemplating Mark's burgeoning popularity as a teenager always makes me think of *Rudolf the Red-Nosed Reindeer*. By his senior year he was president of his class, salutatorian, and star of *Girl Crazy*.

The dearth of childhood trips coupled with his insatiable curiosity about people and places made Mark long to go away to college, but his parents, particularly his father, wanted him close to home. So he went to DePauw University, a scant forty-two miles away. As a junior, he somehow managed to wangle a year abroad at the London School of Economics. It was a watershed year for him. England and all things English, which he studied and explored for the rest of his life at every opportunity, were better than he could have ever imagined, remaining central to his life forever. His drawing ability got him a job with the "hot" decorator of the time, David Hicks, and he and his family became lifelong friends. That summer while he was traveling with some college pals in Italy, we met in Florence, where we fell in love, as our daughter Kate would have it, "with the Duomo, the Uffizi, bistecca fiorentina...and, ultimately, each other."

When he saw that I hadn't quite mastered the Italian driving style (who ever does?), Mark hastily sketched "Scusi" signs embellished with Renaissance gods and goddesses for the side and rear windows of the Morris Minor I was steering through the frightening Florentine traffic. I know that my frequent mistakes behind the wheel were forgiven by other drivers—and, more importantly, the carabinieri—thanks to the whimsy of his drawings.

Mark returned to complete his history degree at DePauw, and, again

acceding to his family's wishes, enrolled in law school at the University of Michigan. He lasted one year. In that year he made some great friends, learned to play the autoharp, and produced a quasi-pornographic folio called *Hampton's Illustrated Torts* (sadly lost to posterity), but accomplished little else. Or, looked at in another way, he accomplished a great deal: he learned he shouldn't continue to work at something he didn't love simply to conform to the desires of others. He switched from law to art history, got a second undergraduate degree in record time, and was accepted for graduate study at the NYU Institute of Fine Arts.

When searching for a summer job that year, Mark was sent by an Indiana artist to see Hilary Knight, the illustrator of the *Eloise* books, who suggested he show his portfolio of sketches to a decorator called Mrs. Henry Parish. As she liked to tell it, Sister hired Mark for his artistic ability, to be sure, but also because he was "this marvelous-looking young boy who reminded me so much of my brother Bayard who died when he was sixteen. I was completely dazed and stunned and immediately sent a note to Mr. Hadley [Albert Hadley, soon to become her partner] saying: 'No matter what, do not lose that boy.'" On the job he excitedly set to work on repeated renderings of what turned out to be a maid's room in Jock and Betsey Whitney's town house. Even from that humble vantage point, Mark learned a great deal about the ins and outs of decorating that summer, not the least of which was an appreciation of "cosiness." To our daughter Kate, it seemed that "cosy was what he prized most." And, certainly, though we passed through several phases of minimalist modern in our own apartments, he came to loathe the sterility of a room in which, he

said, "the only thing out of place is you." Sister and Albert came to our wedding the summer after I graduated from college and were our first friends—practically the only people we knew—when we moved to New York City.

Since we were both from small towns, graduate student life was a perfect way to adjust to the overwhelming scale and bustle of the big city. Marital adjustments were in order as well. Mark taught me to enjoy opera and I introduced him to rock and roll. My sister and I even took him in hand one summer and taught him to dance properly. I banned bow ties, seersucker, and madras from his wardrobe, while he honed his skill at what our daughters and I later termed "The Hampton Seal of Disapproval," his too often correct veto of various outfits and accessories that we thought were divine. I learned that vociferous political, philosophical, and literary controversy didn't necessarily destroy friendships or ruin dinner parties. Mark learned that my occasional noisy blasts of temper didn't signal all-out war—in fact, they allowed him to perfect his maddeningly calm debating-society responses. Since he was outgoing, curious, and incorrigibly sociable, and I tended to be shy and always have my nose in a book, he set out to teach me to enjoy going to parties, receptions, openings, and those gatherings of the sixties called "happenings." Though I still don't subscribe completely to the theory, I now at least have a glimmer of what Mark thought—and Marietta Tree was supposed to have said—"A dull dinner party is always preferable to staying at home with a good book."

Which is not to say that Mark didn't like a good book. As our old friend, Teresa Heinz, said, "He was a voracious reader...he probably read in a year

what most people read in a lifetime." He always made room for reading—on planes, on weekends, and around the edges of work and family life. But socializing both relaxed and stimulated him—and he was good at it. In an article called *The Virtue of Social Graces*, in *Civilization* magazine (December 1998), Michael Thomas wrote, "Mark Hampton was about as socially gifted a human being as I have known. He knew how to organize his friends—a gift for society includes an instinct for conflict avoidance, a talent for when to mix and match that Martha Stewart would envy. As pleasurable as it was to be in his company, it was no less delightful to savor the sight of him working a room....The truly socially gifted are like piano prodigies: born with a pitch, inflection and intonation that cannot be taught. Of course...they must practice...conversation counts for more than accessorization." Mark practiced a lot.

As I toiled away in English Lit in assorted undistinguished buildings around Washington Square, Mark departed daily for the exalted halls of the Duke Mansion at East Seventy-eighth Street and Fifth Avenue, which housed the Institute of Fine Arts. The surroundings were sumptuous, the professors august: Panofsky, Krautheimer, and Pope-Hennessy among them. Classmates included Sam Sachs, director of the Frick Museum; James Wood, director of the Chicago Museum of Fine Arts; and Roger Mandel, president of the Rhode Island School of Design. Upon graduation, Mark was awarded a Ford Foundation fellowship, which included travel abroad and curatorial study at the Metropolitan Museum and the Museum of Modern Art. Although he thoroughly enjoyed his work at those two venerable institutions, he finally decided to do what he had wanted to do for a long time—

become a decorator. The introduction to his first book outlined what it meant to him:

> We all know that interior decoration is seen by many as a frivolous career full of ruffles and flourishes and preposterous fashion statements. Yet to transform the bleak and barren into welcoming places where one can live seems to me an important and worthwhile goal in life. Sometimes this transformation can stun the eye, sometimes simply gladden it, but these are not frivolous pursuits.
>
> In an era when there is increasing despair over the inhumanity of the world around us, the concerns of decorating rather than seeming vain and irrelevant provide for me a wonderful refuge. This work has to do with people and beauty and the timeless activities of domestic life. At least our private worlds can reward us with peace and pleasure.

For a short while Mark ran a one-man show that included acting as a representative for David Hicks in America; then he went to work at McMillen before opening his own firm in 1976. In the ensuing twenty-two years Mark decorated houses, apartments, offices, planes, and private railroad cars. He wrote and illustrated numerous magazine articles as well as two books, *On Decorating* (1989), edited by Elaine Greene, and *Legendary Decorators of the 20ᵗʰ Century* (1992), edited by Jacqueline Onassis. He also launched the Mark Hampton Collection of furniture for Hickory Chair, as well as designing materials for Kravet, Scalamandre, Springmaid, and Valdese. He was a

fabulous lecturer—always eager to share his knowledge and experiences. He never used notes and kept his delivery chatty, anecdotal, and down to earth, displaying what Vartan Gregorian termed "a discerning and impeccable taste, a critical, disciplined, and catholic mind, a prodigious memory, an enormous range, and an in-depth knowledge of art, art history, architecture, and design as well as history, literature, and music."

The New York–based architecture and design critic Martin Filler felt that Mark was "a journalist's dream. I could ask him about anything. He knew the buildings of Shinkel, the name of an obscure old chintz, the best place in New York to buy English majolica, the provenance of a tycoon's wife's Golconda diamond from the Westminster tiara…'just don't ask me about baseball,' he once told me when I seemed impressed."

Work on period buildings was of particular interest to Mark, and constant travel to and dedicated study of architectural and cultural monuments around the world had prepared him well. He worked on renovations of the governor's mansion in Albany, New York; Gracie Mansion (home to New York City's mayors); numerous historic houses in New Harmony, Indiana; and interiors at the Metropolitan Museum in New York and the National Gallery in Washington, D.C. He was chosen as one of two decorators to undertake the complete overhaul of Blair House, the president's official guesthouse, during the Reagan administration, while at the same time decorating the vice president's residence for Barbara and George Bush. The Bushes moved to the White House in 1989, and Mark became known as "First Decorator" when he turned his talents to the redoing of the private quarters, the treaty room, and the Oval

Office in the White House, in addition to working at Camp David and the "summer White House" in Kennebunkport, Maine. While remaining on the Committee for the Preservation of the White House during the Clinton administration, he continued to work for the Bushes in their new house in Houston and on George Bush's presidential library in College Station, Texas. Farther afield, Mark carried out renovations on the American Academy in Rome and decorated the private quarters for Ambassador Pamela Harriman at the United States embassy in Paris. He even went back to design the faculty commons room at the University of Michigan Law School.

Adele Chatfield-Taylor, president of the American Academy in Rome, observed—in a ceremony in the spring of 1999, dedicating a room in the academy and a fellowship in his honor—that "Mark was routinely described as a Renaissance man, because [in addition to being a decorator] he was also a considerable art historian, a builder, a reader, a writer, a gardener, a painter, a musician, an avid traveler, a man of wildly high spirits and IQ, and a screamingly funny, champion friend."

Repeatedly going on record as having "absolutely no interest in a trademark style," Mark approached each new project with an eye to creating a comfortable, functional, and aesthetically pleasing environment to enhance the lives of those who would inhabit it. He believed, as an early adviser had put it, that "the perfect interior designer, like the magician, must be a past master of the art of disappearing." He worked his magic for the Carter Burdens; Jacqueline Onassis; the Thomas Kempners; Estée Lauder; the Saul Steinbergs; Anne Bass; the Parker Gilberts; the Mike Wallaces; the Henry

Kissingers; and Senators Ribicoff, Heinz, and Kerry among many others. During the course of his career he became a mentor to a long list of decorators currently working around the world, including his sister-in-law Paula Perlini and, most significantly, our daughter Alexa. She carries on her father's legacy not only by heading his firm, but also by designing her own furniture, fabrics, and home furnishings—and drawing and painting in both oil and watercolor.

Paige Rense, editor in chief of *Architectural Digest*, said of Mark, "He knew the history of decoration internationally more than any other person I have ever encountered. He conducted his career in a way that gave stature to all of those involved in interior design and decoration…and he was a great dancer." Architect Jacquelin Robertson cites Mark as a "rarity among decorators. He loved Architecture…*thought architecturally*. [He knew] what architects in which places and in what periods had shaped our culture—whom they had been influenced by, what they had copied, revised, re-invented, abandoned. And he could cite the source books, turn to the drawings, photographs, and the details as precedents." He goes on to describe him as "a tolerant, educated, worldly urbane gentleman; 'old style,' but new and better—because he was also a *free spirit*…the best kind of American mix." And, in the same vein, with only the tiniest hyperbole, William Norwich dubbed Mark, "the last of the twentieth-century American gentlemen."

Writing in the *Providence Journal* in August of 1998, Froma Harrop makes some wise and thoughtful observations about Mark's decorating and writing: "Hampton had a lot to say about the demons that drove both his fancy clients

and ordinary Americans to acts of home-decorating desperation...his object was to help people conduct authentic lives. No other American possession says as much about its owner as a house. [Hampton], however, believed that the American home should function chiefly as a servant of its occupant, not its spokesman....[He] knew that people, not chandeliers, were what made a house lovely...that whatever the size, expense or ZIP code, a house can only be great when it is arranged to honor daily life."

Honoring daily life was at the core of Mark's character. His integrity, honesty, and humor, his capacity for and love of friendship made him connect with a vast array of people. In her syndicated column Liz Smith wrote, "Mark was the most amusing, cleverest, nicest, most cultured, kindest, funniest guy in all New York...one of those Midwest success stories—a true talent who shook the dust of Indiana off his feet and made it in the big city." She was right, of course, but she was probably not aware of how regularly his feet got "redusted." He never forgot his Indiana roots. We traveled there—and to Illinois to visit his sister's family—often, and our daughters really got to know their army of aunts, uncles, and cousins (and their friends and neighbors, too) from dozens of shared holidays, weddings, christenings, and reunions.

Friends became family as well. Mark moved into people's lives in the nicest possible way—staying abreast of their joys and tragedies, storing hundreds of arcane facts about them in his amazing memory. As Susan Burden said, "He knew [friendship] took time; so he saw us, and called us, and sent postcards whenever he traveled. He expressed interest in what we did and said and thought. He embraced our families and knew our parents and siblings. He

remembered everything important that was happening in our lives and never forgot a birthday or anniversary. [If my house were on fire] Mark's magnificent cards would be the first thing I'd save after the people and the dogs."

Virtually all of the watercolors in this book are Mark's presents to friends and family. Selecting what to include from the many hundreds he painted was a monumental challenge. They are grouped here loosely as interiors, exteriors, homages, still lifes, flowers, and the like—though of course many defy simple categorization. Each one represents an investment of time, effort, thought—and love. Some are playful; some are rich in iconography; some are specific references to other artists; and some are merely beautiful. They were painted with care to celebrate friendship. Writing in the *New York Observer* the week after Mark's death, Michael Thomas said, "With Mark, friendship was always about you, never him. [He was] a life-enhancer such as Bernard Berenson could only dream of....He lit up so many lives....As a designer he was an undoubted genius, but as a friend he was a miracle."

Names are subject to the winds of fashion. Sometimes a famous person or place will inspire us; sometimes it will be a time (i.e., "Olympia" just after the games); sometimes a first name just sounds right when combined with a last. In 1907, Mark's mother, Alice, was named after the president's daughter—thus Mark's birthday watercolor for her.

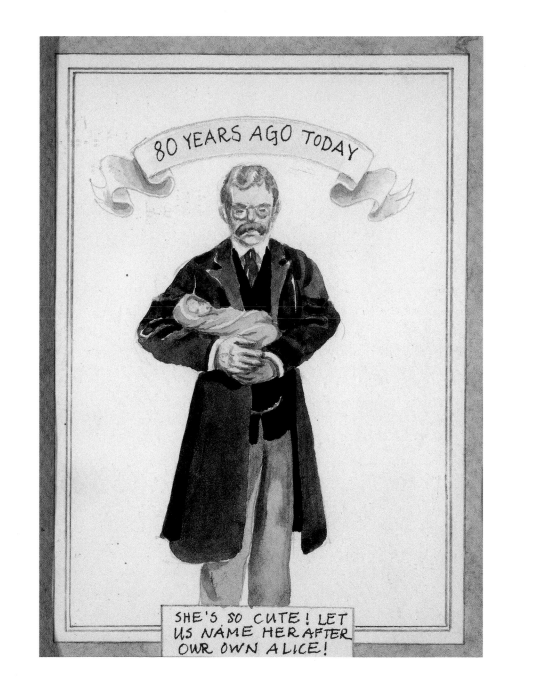

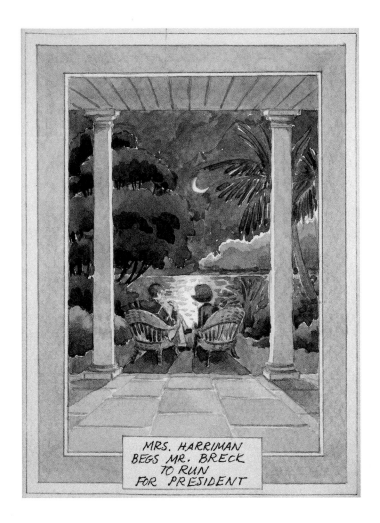

MRS. HARRIMAN
BEGS MR. BRECK
TO RUN
FOR PRESIDENT

After a visit to the Henry Brecks in Barbados that included a dinner with the seductive Pamela Harriman, Mark was inspired to paint this card for Henry's birthday. It depicts the famous political kingmaker on her ocean-front lawn under the full moon working her wiles on a willing listener.

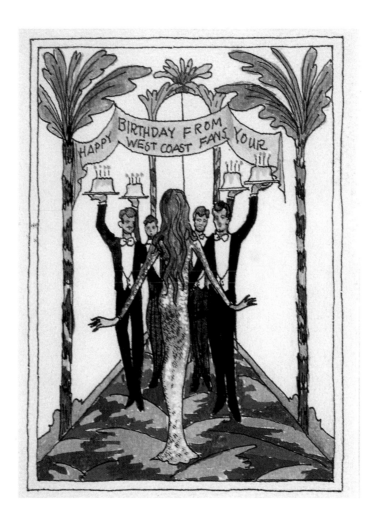

Lyn Revson, famous for her terrific collection of slinky, sequined Norell dresses (and the figure to go with them), was heading off to California to celebrate when Mark produced this.

As much an admirer of eighteenth- and nineteenth-century English grandees and their houses as he was a loather of the telephone, Carter Burden is pictured here as a pipe-smoking Whig in a grand hall filled, anachronistically, with telephones of all sorts.

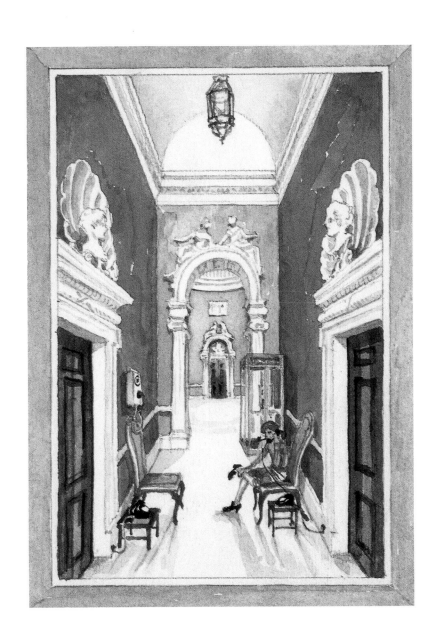

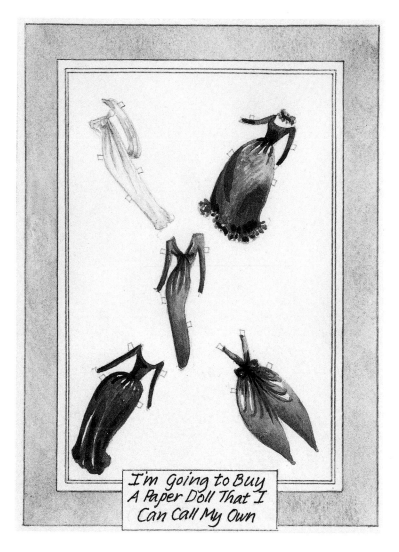

I'm Going to Buy
A Paper Doll That I
Can Call My Own

One of my cards from the early eighties is painted with an assortment of my favorite outfits—perhaps to remind me of how lucky I was?

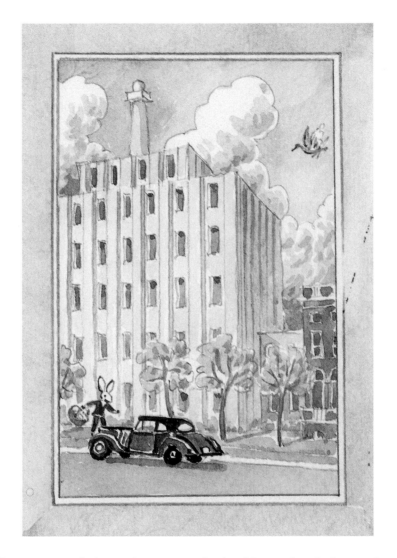

Mark's sister, Rachel, was born at Methodist Hospital in Indianapolis at Easter time. He painted this to remind her of the race between the stork and the Easter bunny to see which would get there first.

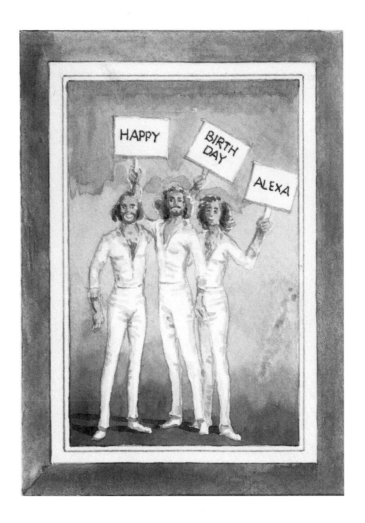

The Bee Gees were tops in our family (and are still right up there) when
Mark painted this card for a quite young Alexa.

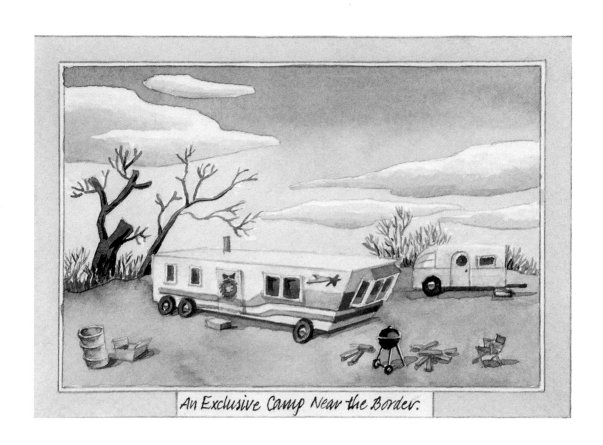

An Exclusive Camp Near the Border.

The true glamour of a hunting camp in West Texas is depicted in this card painted for one of our favorite Texans, Joe Hudson.

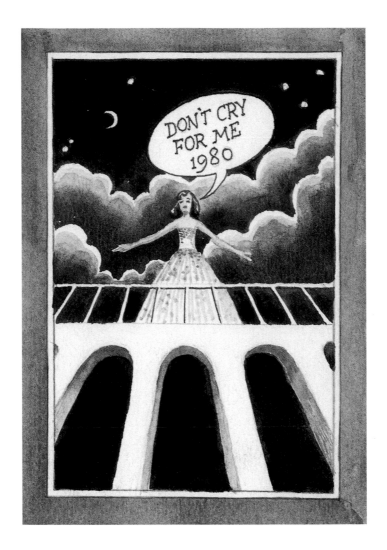

Our budding actress, Kate, had just been dazzled by *Evita* when Mark created this to put her up on the parapet.

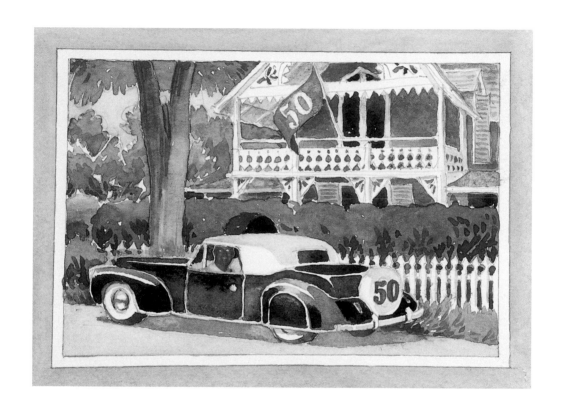

Tom Fallon, who lives in this charming cottage on Shelter Island, New York, threw a fifties birthday party for himself on his fiftieth birthday, and Mark painted this to commemorate it.

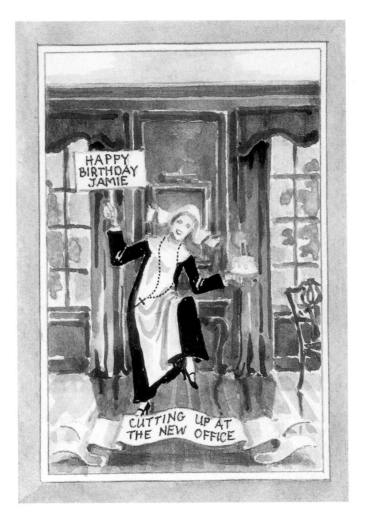

This was painted for Jamie Niven as he was moving into a new office.
The dancing nun is his former wife, Fernanda, who had appeared as one in
a Woody Allen movie (making us all wildly jealous); Mark just scrambled
all the events together.

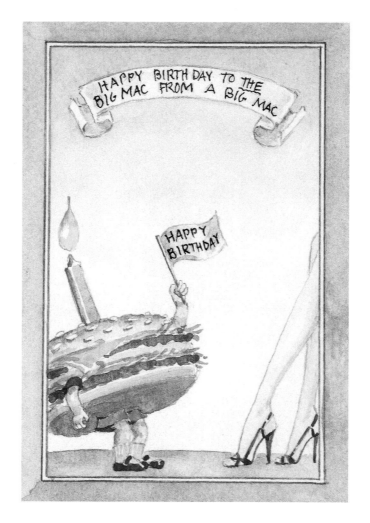

Leola Macdonald was a big-time friend of Mark's, and this pictorial confrontation doesn't have anything to do with her size, as is apparent from those dainty legs and feet.

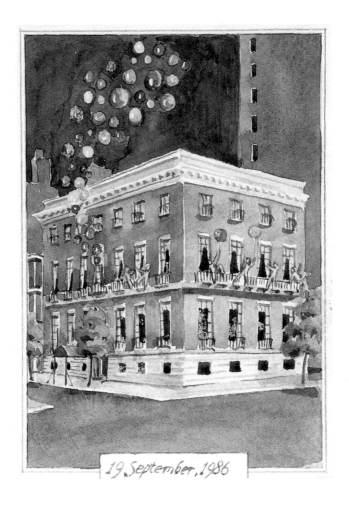

19. September, 1986

The Knickerbocker Club at East Sixty-second Street and Fifth Avenue was the location one year for the party of a great friend who insists on celebrating her birthday properly each year—and I heartily concur!

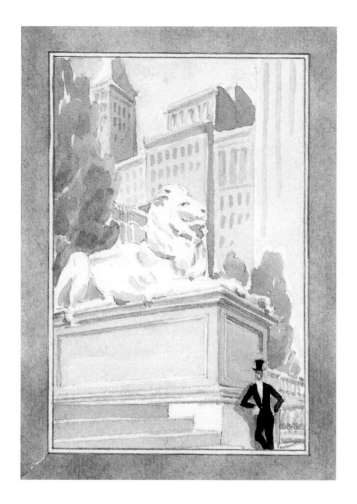

Our fourteen-member reading group began in 1971 by reading Proust. On our tenth anniversary, former member Richard Avedon took a picture of us in front of the New York Public Library. In that photograph, Ashton Hawkins sat on the lion wearing a top hat, inspiring this card that pictures him as *Baron Charlus*.

The ever-graceful Teresa Heinz is depicted here as waltzing unfazed through yet another birthday, top to toe in Chanel.

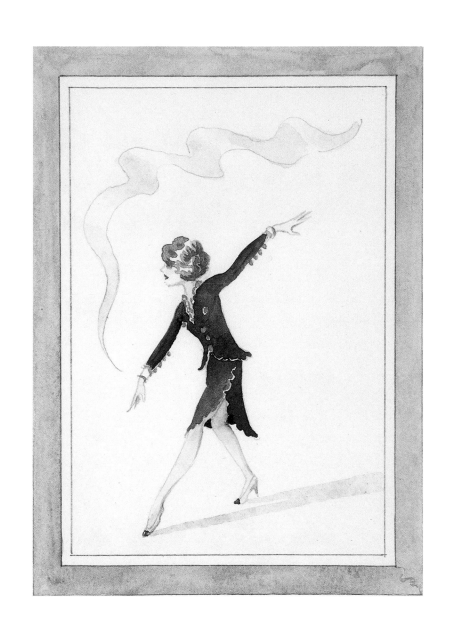

On West End Road in East Hampton, New York, this beach house was the Burden family retreat in the 1970s, when all of our children were small. Both of our families are marching in Susan's birthday parade, with either Carter or a pug at the wheel, probably the latter.

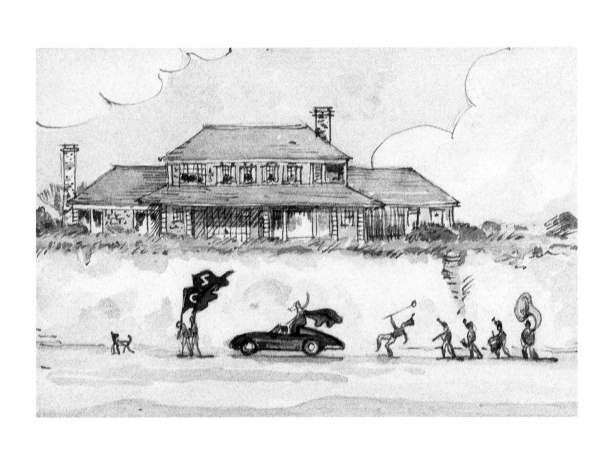

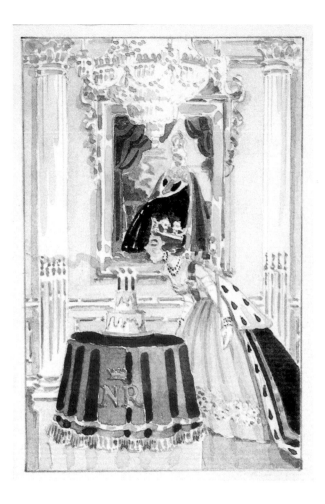

Nell Sawyer dubbed her house the QE II because it was large and on the
Atlantic Ocean, so Mark painted the other QE II as a visitor helping to
blow out Nell's birthday candles.

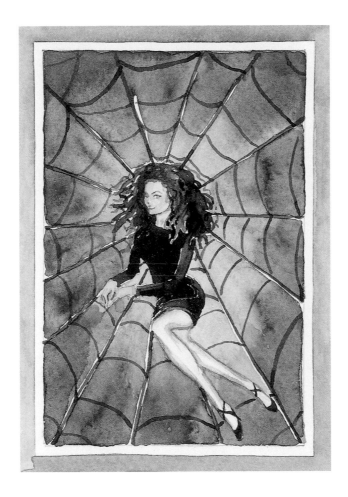

Kate was studying drama in London on her birthday, so we flew over to celebrate with her. She wore the dress on the card to the theater to see *The Kiss of the Spider Woman* the night we got there, and Mark had this watercolor on her breakfast tray the next morning.

In this "Obeisance to the Pasha" card, Mark is trying to make turning forty more appealing than it really was for Tony Robinson, or anyone else for that matter.

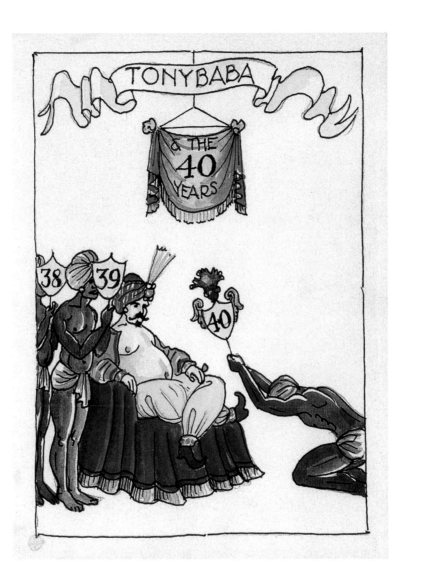

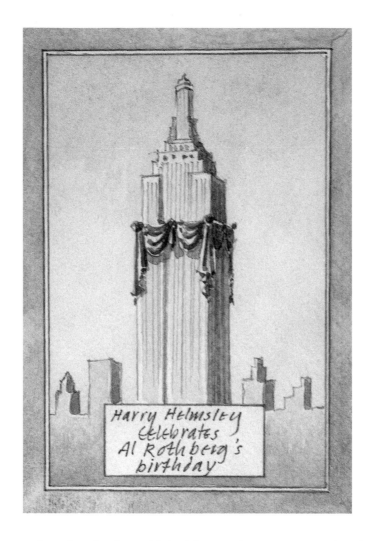

Harry Helmsley
celebrates
Al Rothberg's
birthday

Mark's great friend and cohort Al Rothberg, a famous New York upholsterer
and draper to the stars, received all manner of drapery-themed birthday cards.
This one was chosen because it's about the city and the passage of time.

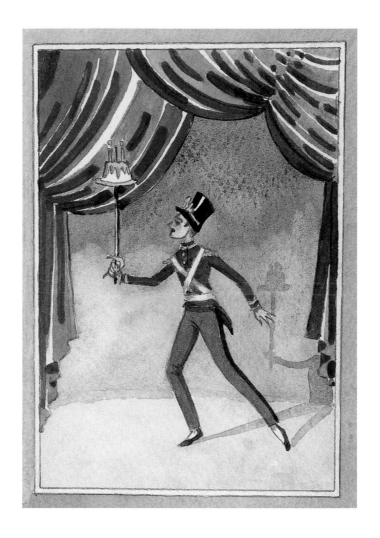

When she attended the School of American Ballet, Kate was the tallest soldier with the shortest pants in *The Nutcracker*—it was easy to pick her out in the crowd. It was also easy for Mark to decide what to paint for her birthday.

After having been dragged all over Tuscany and Umbria by Henry Breck to view the battlefields of Hannibal's army, Mark was unable to resist attributing an apocryphal battle to the site of our charming rented farmhouse.

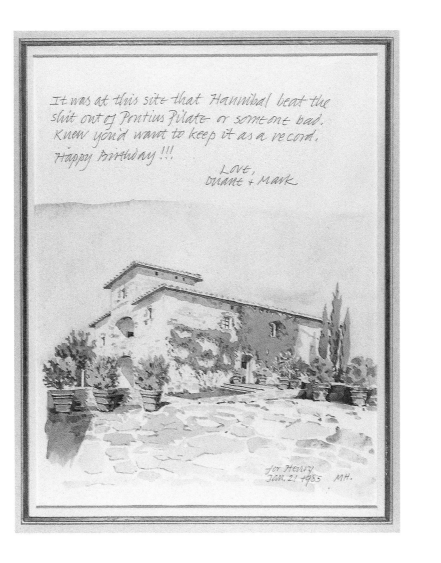

It was at this site that Hannibal beat the shit out of Pontius Pilate or someone bad. Knew you'd want to keep it as a record. Happy Birthday!!!

Love,
Duane & Mark

for Henry
Jan. 21 1985 MH.

The Metropolitan Museum as a giant birthday cake! What could be more appropriate as a card for its general counsel? I wonder if Mark got the right number of candles?

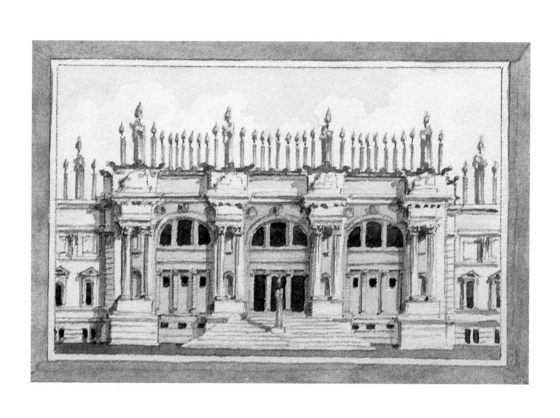

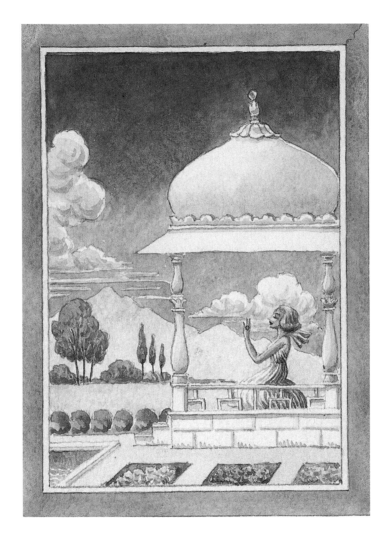

This was painted for my birthday after a trip to India—I think Mark *hoped* that meditation had become part of my routine.

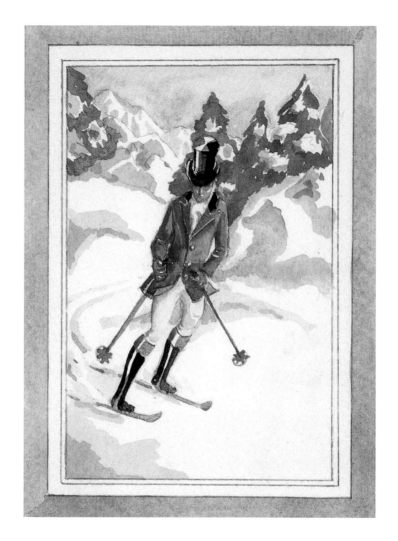

Nathan St. Amand, a riding and skiing enthusiast, is depicted dressed for one sport while pursuing the other.

After we toured Wilton outside London, eight-year-old Kate was asked what her favorite part of the legendary house had been. She immediately answered, "Fred Astaire's dancing shoes in the glass case in the hall!" She and Alexa always adored dancing with their father, and in this card the teenage Kate is pictured as Ginger to Mark's Fred (note Fred's bald spot).

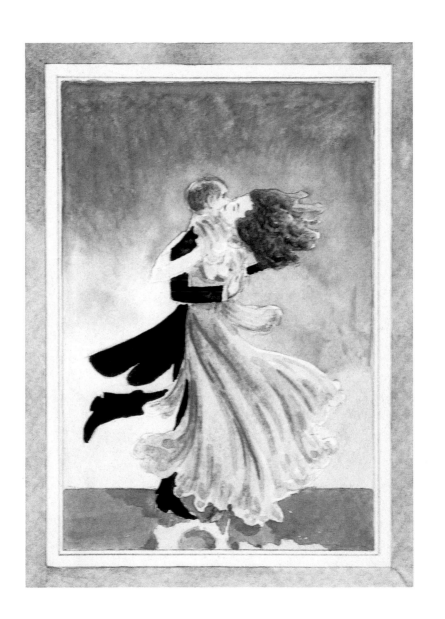

Dorothy Robinson, who has a fancy for 5s, received this card when she turned fifty. All those 5s in the rainbow are appropriately pouring into a pot of gold—since gold is also the metal for fiftieth anniversaries. Note the 5s in the sky and in the stream.

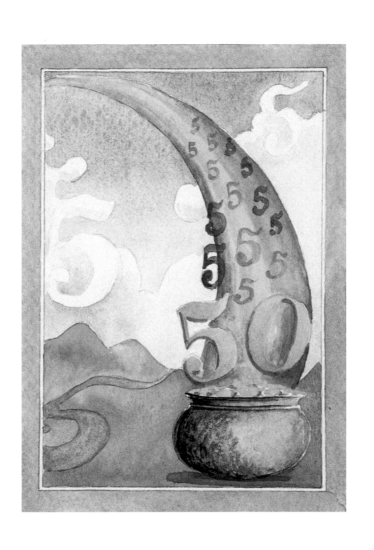

The Nicholas Martin production of *Full Gallop* was a play about Diana Vreeland written by an actor/author named Mark Hampton. People thought Mark had dashed off a play in his spare time, and we were inundated with phone calls from everywhere, congratulating Mark and asking for tickets. It was a nuisance, but it did produce a great idea for my next birthday card.

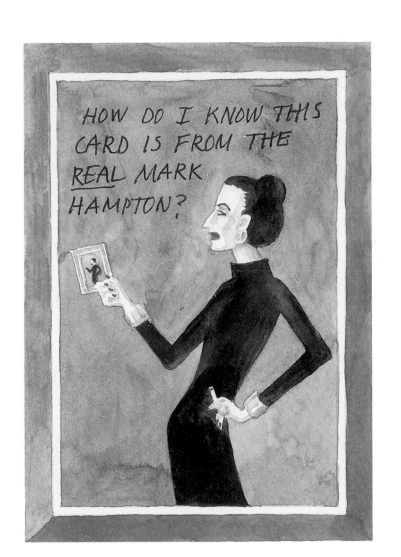

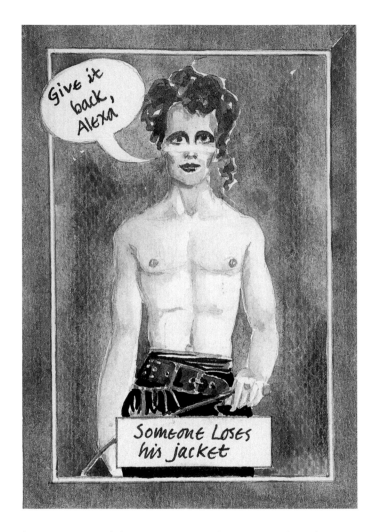

When Alexa was crazed for pop singer Adam Ant, I found a vintage jacket for her birthday much like the one he wore—and brilliant Mark immortalized it with this card!

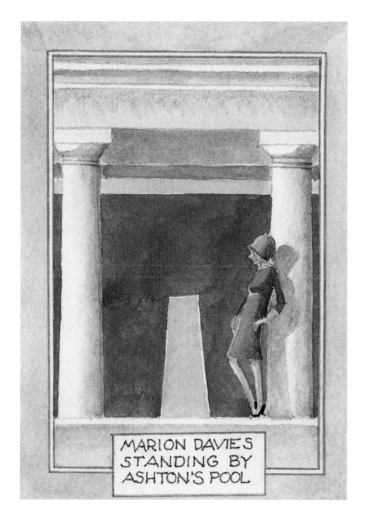

MARION DAVIES
STANDING BY
ASHTON'S POOL

This card celebrated the completion of Mark's work on Ashton Hawkins's apartment, which included adding columns to divide rooms. His new "castle," like San Simeon, only needed Marian Davies beside his Hockney paper pool.

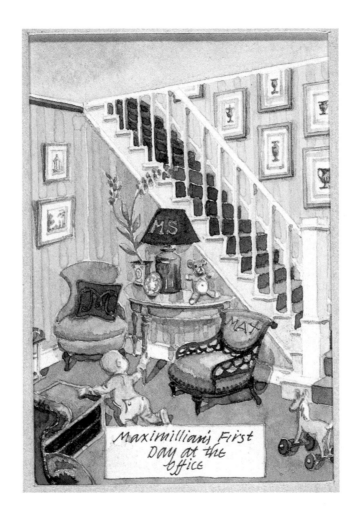

Maximillian's First Day at the Office

Max, the adorable baby son of our friends the Stenbecks, is pictured in this card in a situation that would unnerve most parents—visiting his mother's antique shop. Since both the baby and the shop were hers, presumably she remained calm.

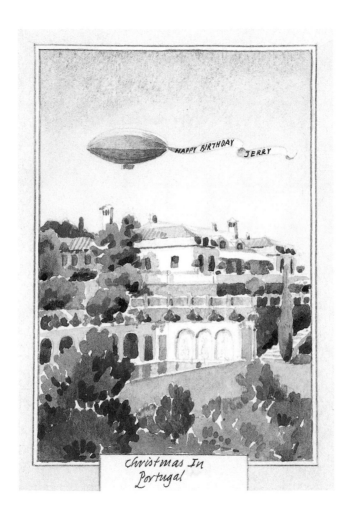

christmas In
Portugal

The Patiños were great friends of Jerry Zipkin's, and he would often visit
them in Portugal. Mark painted this view of their incredible house with the
Zipkin birthday blimp floating over it as Jerry's present one year.

Because our family had just been to a very lovely wedding in Venezuela, Mark painted the three of us in the beautiful old cathedral in Caracas for my birthday card that year.

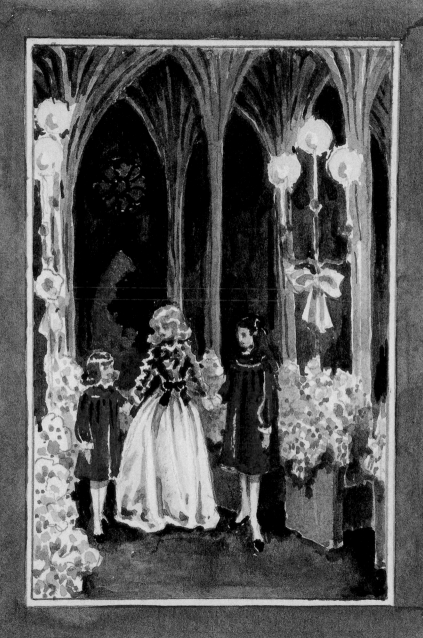

Mark painted this hypothetical Parisian location for the equally hypothetical foreign branch of the antiques shop Louise Grunwald and I ran in the 1980s.

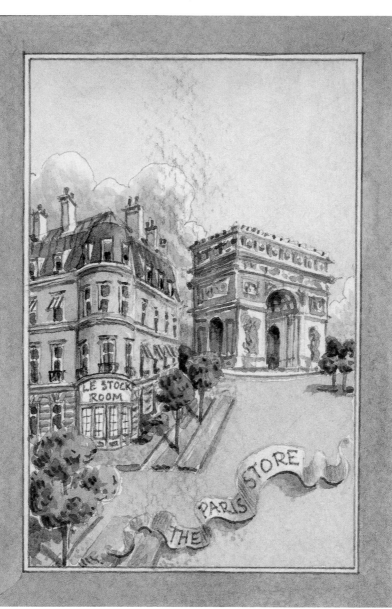

In a nod to the grand Victorian royal processions, Mark imagined the festivities of Jerry Zipkin's seventy-fifth birthday celebrations in London.

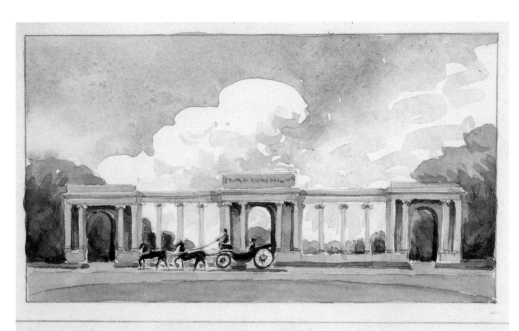

Mr. Zipkin's Diamond Jubilee, December 18, 1989
The Carriage Passes Hyde Park Corner

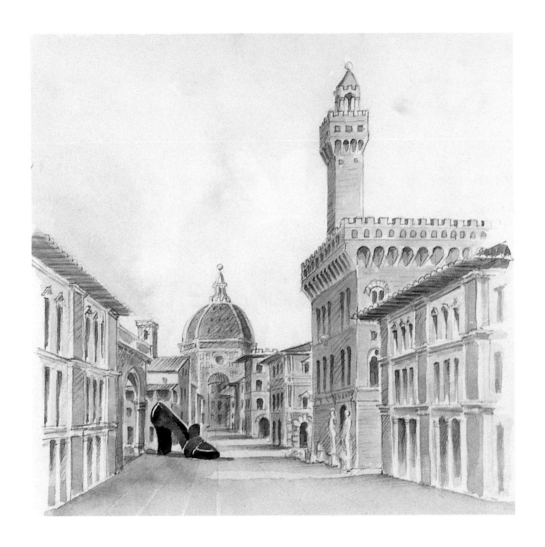

Alexa had a birthday in Italy while doing graduate work, so Mark envisioned her shoe firmly planted on the stones of Florence.

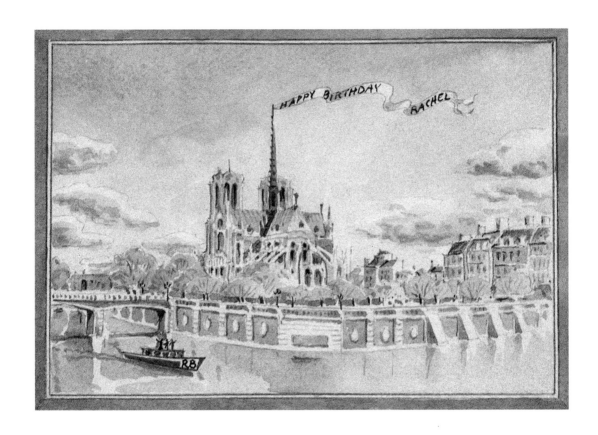

Since she was celebrating her birthday in Paris, Mark's sister, Rachel, was depicted sailing before Notre Dame on her own *bateau-mouche*.

Inveterate traveler Pattie Sullivan heads for the hills containing her dream goal—all the world's great architecture in one place!

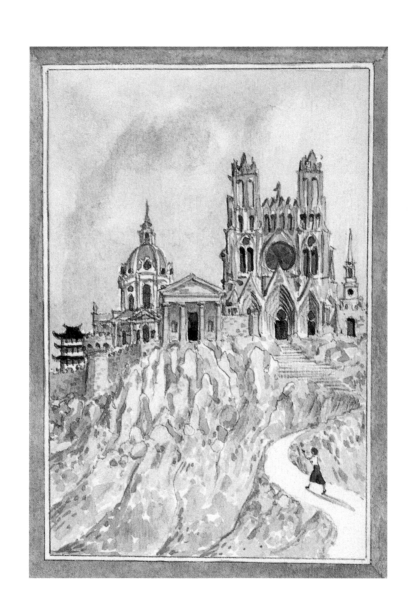

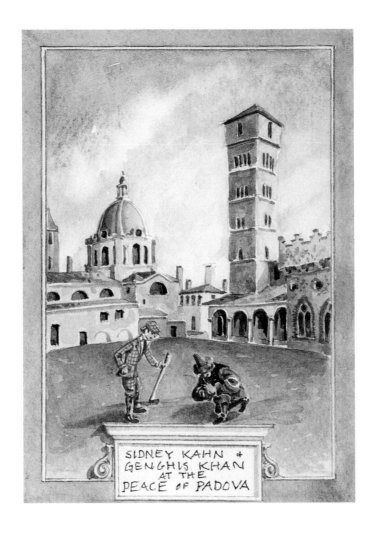

SIDNEY KAHN &
GENGHIS KHAN
AT THE
PEACE OF PADOVA

A favorite of mine, this watercolor fantasizes a meeting of our friend and golfer, Sidney Kahn, with a putative ancestor. Sidney had spent the summer in Italy searching for golf courses to play between museums.

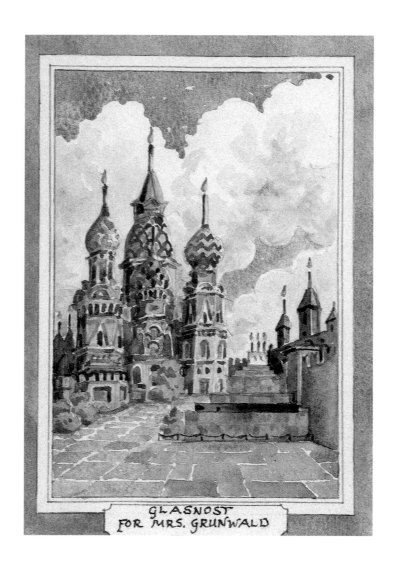

GLASNOST
FOR MRS. GRUNWALD

This watercolor commemorates a Grunwald journey to Moscow.

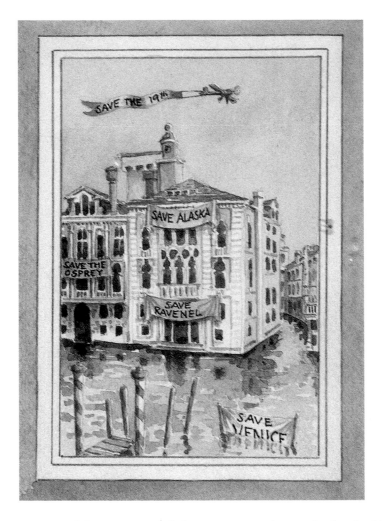

Reflecting some of the concerns of the recipient, who works for the Natural Resources Defense Council, this watercolor contains a flying "save the date" notice of her birthday.

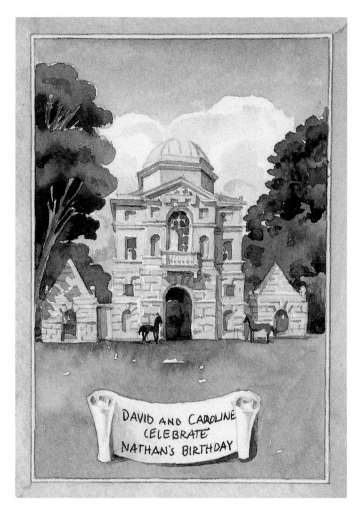

This gatehouse/folly at Badminton House in England is decked out in honor of Nathan St. Amand's birthday, since for years he never missed the famous "horse trials" there.

This is the beach at Cave Bay on the east coast of Barbados, a favorite picnic spot of our friends Wendy and Henry Breck. The natural rock formations and pounding surf make it exciting; what doesn't make it exciting is lugging picnic supplies up and down those steep steps!

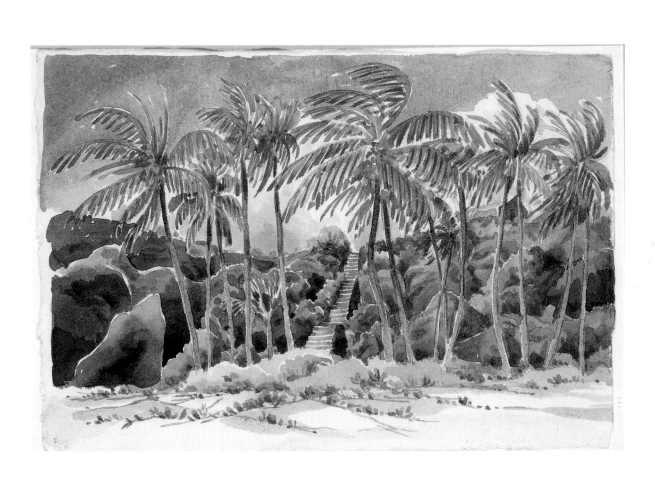

As a thank you for a fabulous visit, Mark sent this painting of the front gate of their exotic compound in Bodrum in Turkey to the Ahmet Erteguns. The buildings are said to be practically on top of the tomb of Halicarnassus.

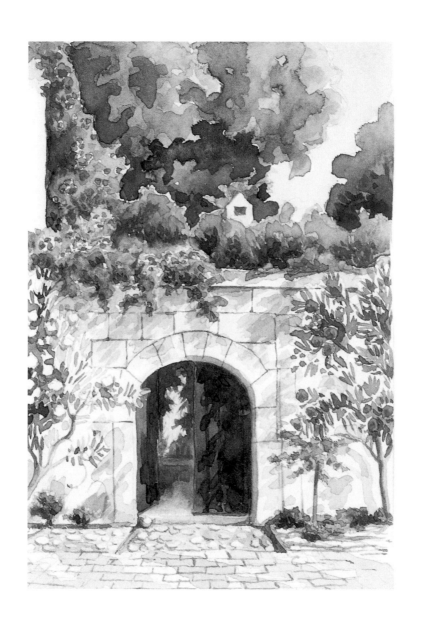

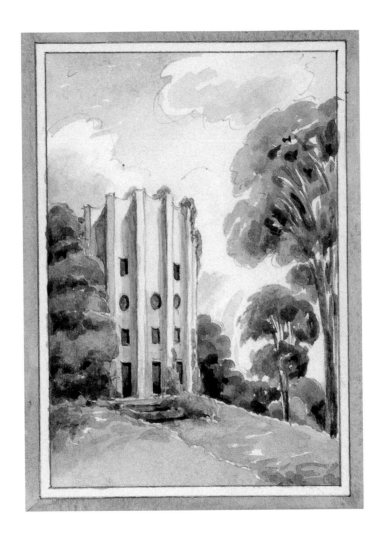

Mark painted his own version of the tour de Retz in that mysterious garden
outside of Paris, the Desert de Retz.

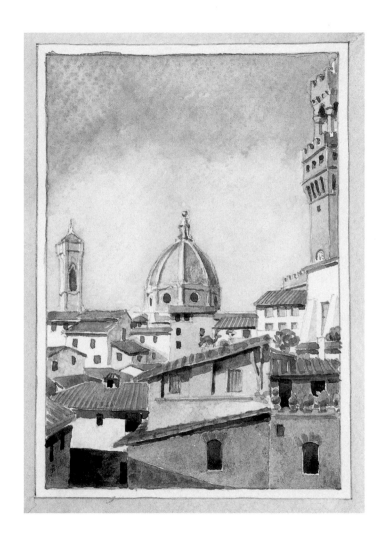

This view of the rooftops of Florence, the town so significant in our life, was painted for our thirtieth anniversary.

Kate studied in Rome after college and fell in love with the Pantheon. She asked her father for a large painting of it, and he complied with this 18" x 22" watercolor.

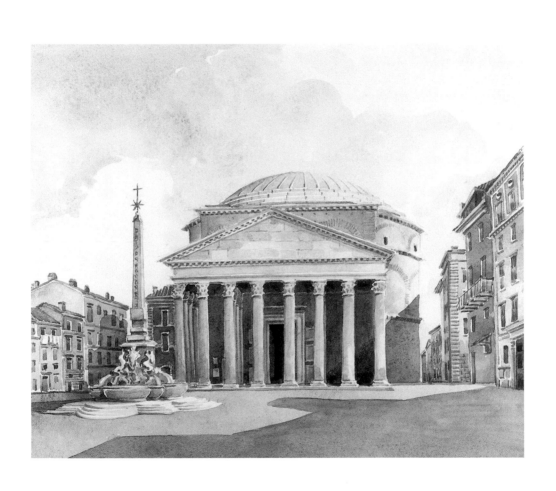

Sophie Consagra, former president of the American Academy in Rome, who first involved Mark in his restoration work there, was the recipient of this view of the nineteenth-century Villa Aurelia. The villa, sited at the highest point on the Janiculum Hill, with the most beautiful view imaginable, is part of the complex of buildings owned by the academy.

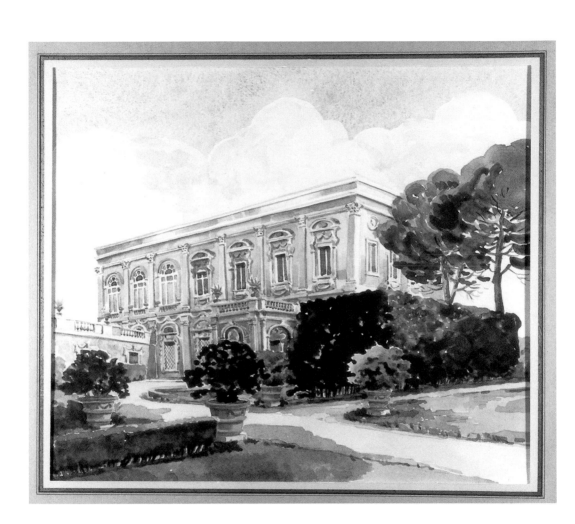

A recent trip to Egypt was the impetus for this card for the Brecks, whose annual "surprise" birthday/anniversary celebration produced an annual card from Mark.

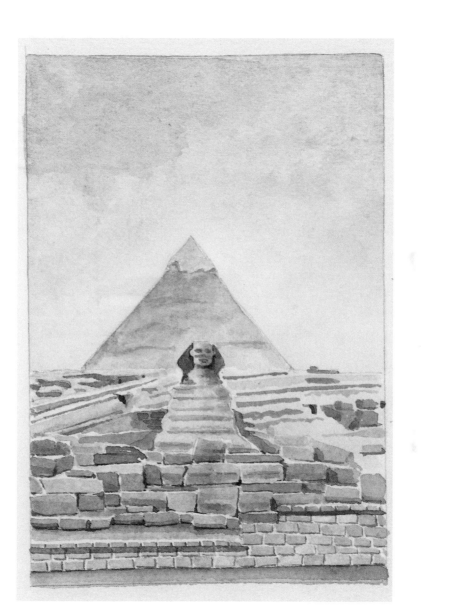

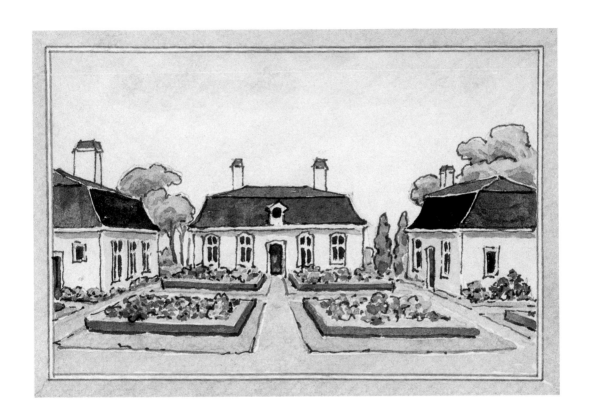

This is a painting of the charming farm outside Stockholm, named by our friends the Stenbecks "Christineholm," in honor of their elder daughter. Individual buildings for family, guests, and dining are arranged around a central garden.

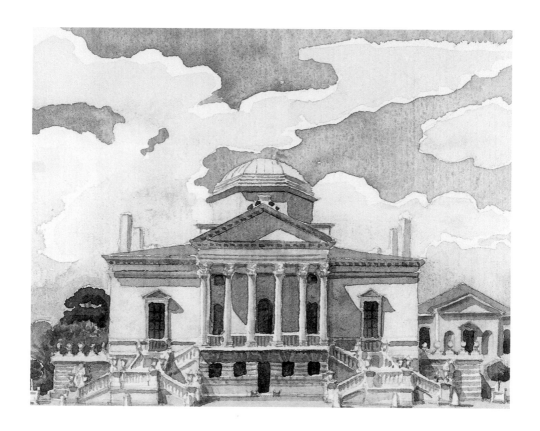

Chiswick House, on the outskirts of London, was designed by Lord Burlington and William Kent circa 1725, based on Palladio's sixteenth-century Villa Rotunda near Vicenza. Both Palladio and Kent had prominent places in Mark's architectural pantheon.

After our great friend Vartan Gregorian was named president of Brown University, Mark and I often visited him and his wife, Clare, in their beautiful brick house in Providence, Rhode Island. This painting was done as a thank you for a particularly hilarious weekend.

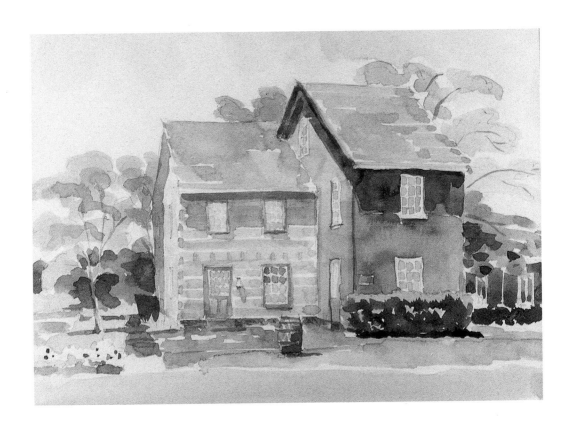

Jane Owen spearheaded the restoration in New Harmony, Indiana, of many of the buildings original to the utopian society that settled there. Mark fortunately got to work with her on many of them and sent Jane this watercolor of the Gate House, a Harmonist log cabin, painted in 1974.

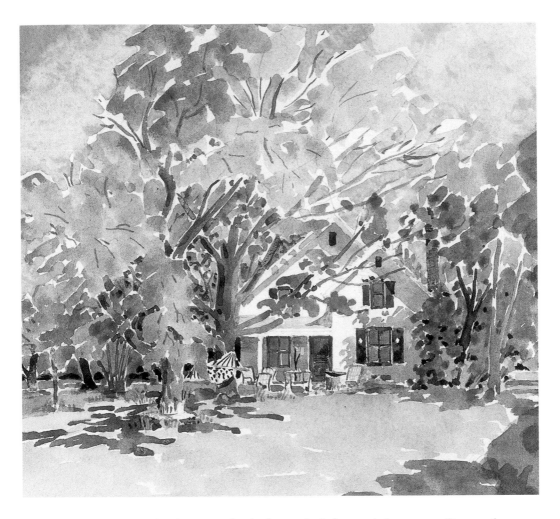

Our best man, Charles Eisendrath, his wife, Julia, and their sons, Ben and Mark, live in this tranquil farmhouse on Lake Charlevoix in the summer. As roommates, Charlie and Mark shared the same one-year law school experience—and the less tranquil aspect of Charles's life now is spent as chairman of the journalism school at the University of Michigan.

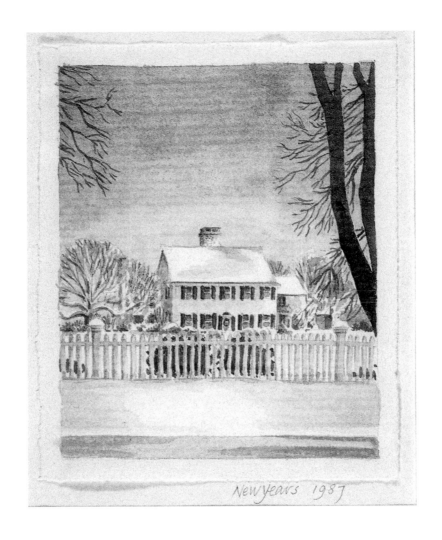

New Years 1987

This nostalgic American winter scene was painted for Gail and Parker
Gilbert of the house in Southampton, New York, where they always gather
friends for a family party on Christmas Eve. And *sometimes* it snows!

Also in Southampton, but seeming worlds away, is the imposing but welcoming "dacha" of Mica and Ahmet Ertegun. Mark painted it shortly after it was built in the early nineties; there are now extensive flower gardens, many more trees, and oversized pots of ilex on the wide front steps.

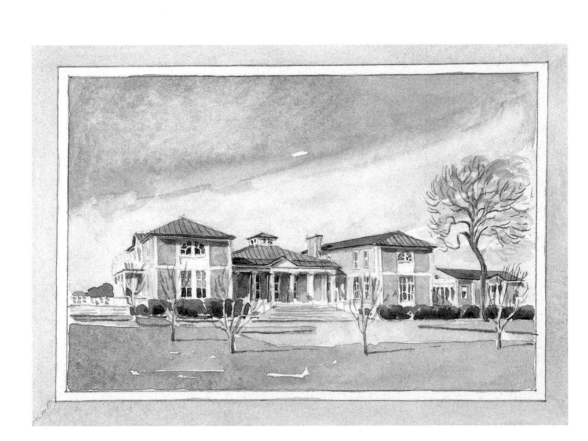

Mulberry Plantation, outside of Charleston, South Carolina, is in the Register of Historic American Houses. The beautiful mellow brick house is on a hill overlooking wide rice fields. The central block of the house has small rooms called "flankers" on each corner. After Hurricane Hugo in 1988, the house was restored beautifully by the Parker Gilberts, who added a guesthouse and undertook the huge chore of bringing the gardens, lawns, and woodlands back to even more than their former glory.

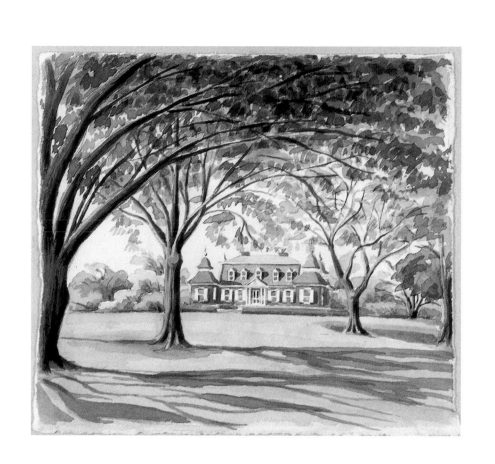

This house in New Preston, Connecticut, is owned by Bill Blass. It sits on the top of a hill and was originally a tavern. Land, trees, cottage, house, and host are all perfection.

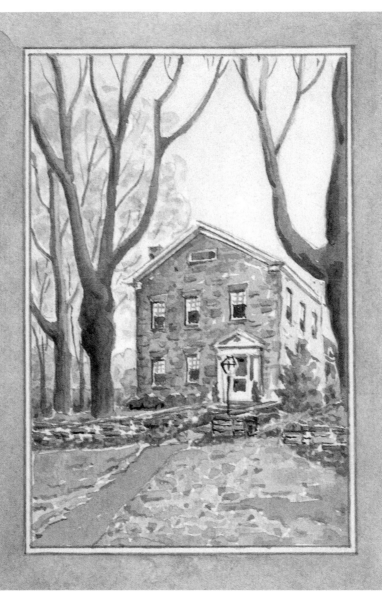

This fabulous neoclassical house faces west high on a bluff over Fort Worth, Texas. It belongs to Mercedes and Sid Bass, who fill it constantly with friends and family and their own warm welcome.

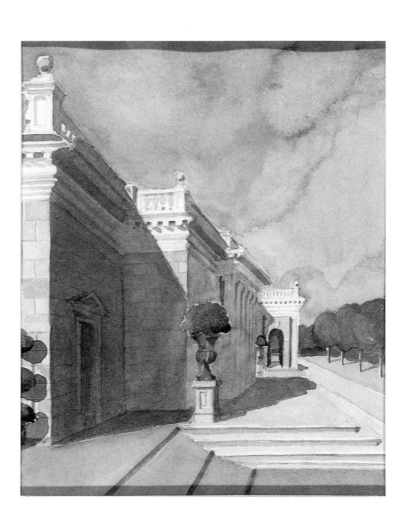

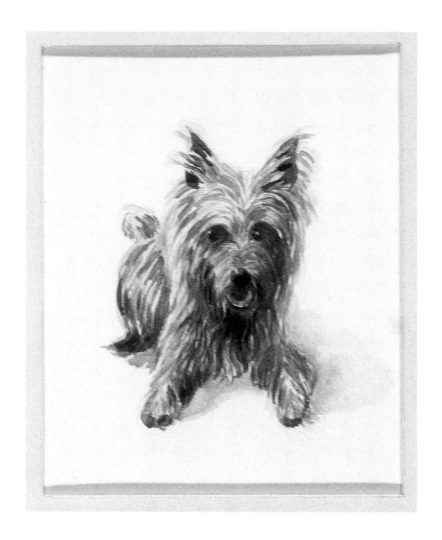

Harry is the adored Australian terrier/child of Henry and Louise Grunwald. Harry loved Mark (he didn't bite him once!), and this painting really "got his loving expression," according to Ma Grunwald.

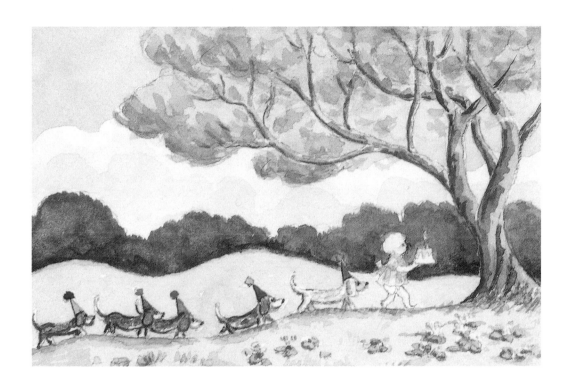

The crowd of bassets who live with our friends the Stenbecks are pictured here in a birthday parade, following elder daughter Christina and her cake.

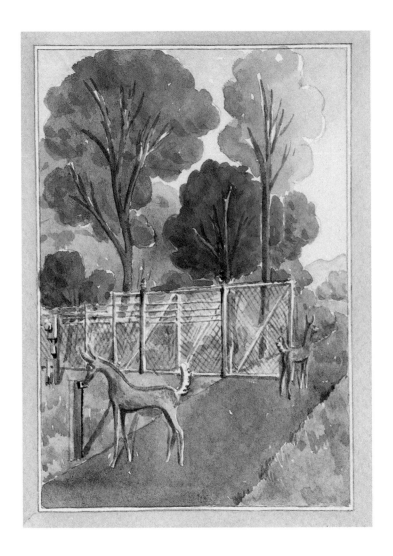

Ruth Carter Stevenson named her house in Roaring Gap "No Deer" in the wild hope that her newly constructed "deer fence" would save her beloved garden; Mark shows a deer pushing the button that opens the gate.

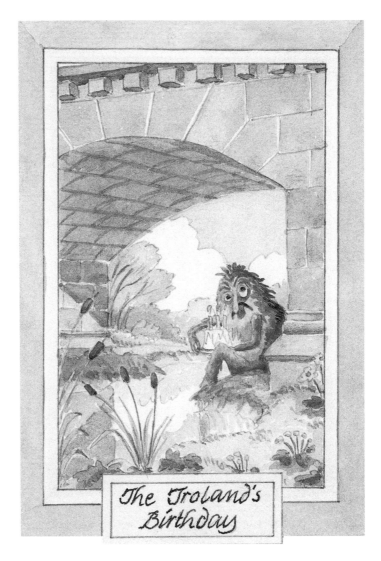

The Troland's
Birthday

Since our friend "Fritz" Link's given name is Troland, Mark couldn't resist plac-
ing him under a bridge awaiting Billy Goat Gruff.

This was painted for Hilary (one *l*, please!) Califano and features her favorite Pekinese frisking about on her porch in the country.

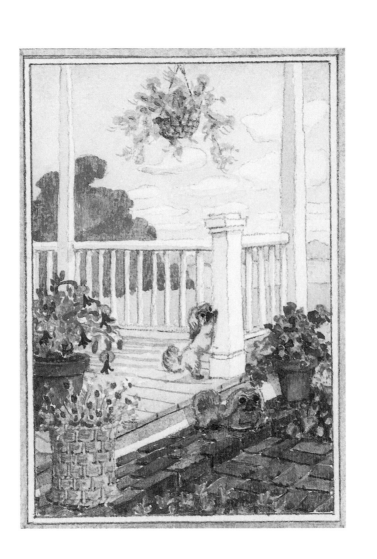

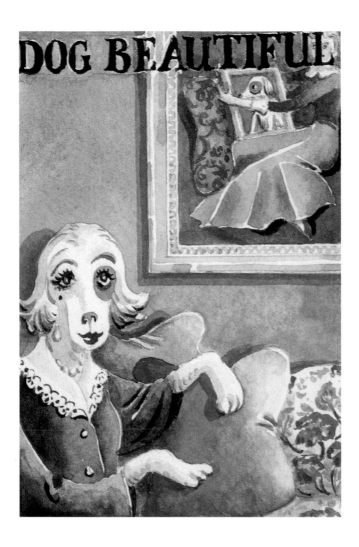

Princess Eboli, the beloved English setter of my sister Paula, was immortalized by Mark on the cover of *Dog Beautiful*.

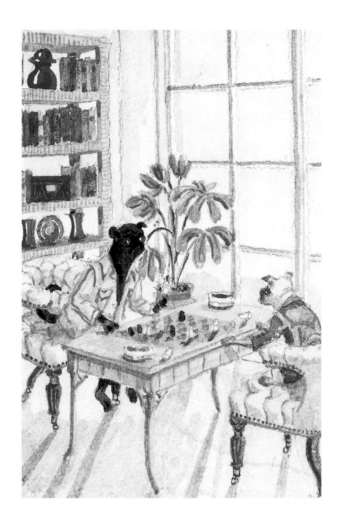

The hard-boiled Burden pugs are playing a cutthroat game of chess in *their* beach house in East Hampton (and did they ever own the place!).

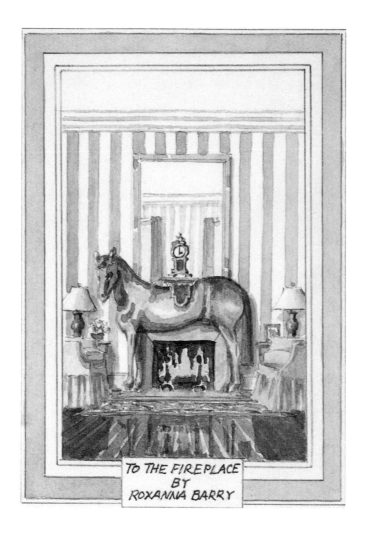

TO THE FIREPLACE
BY
ROXANNA BARRY

Virginia Woolf admirer Roxana Barry (who also writes as Roxana Robinson) had produced an article called "The Horse as a Heater," and Mark came up with this idea to commemorate it.

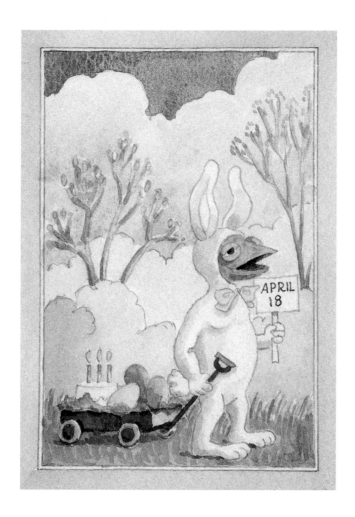

His favorite storybook character, Toad of Toad Hall, dresses as the Easter bunny in this watercolor celebrating author Michael Thomas's birthday that fell on Easter the year this was painted.

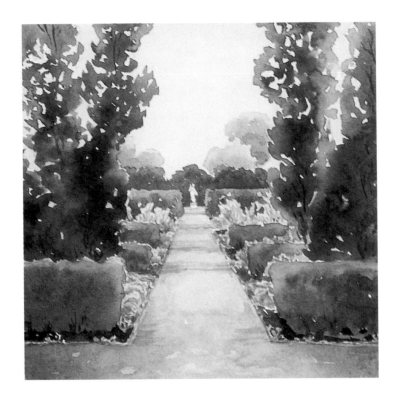

The beautiful Luytens-inspired formal gardens of Paul Walter in Southampton, Long Island, are pictured here in misty August light; this was the view from his arts and crafts house.

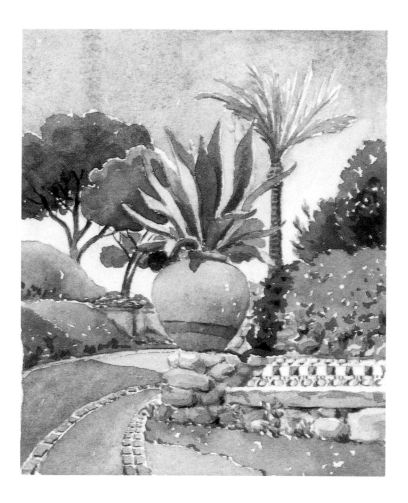

Beyond its high wrought-iron gate is this curving entrance to the gardens of the Villa Aurelia, high on the Janiculum Hill and part of the American Academy in Rome.

This is our garden in Southampton, looking from under the apple trees toward a white fence covered with climbing roses. On the left is a vine- and rose-covered pergola; to the right is a garden bench draped in clematis. The garden is sectioned into four beds, bordered by low boxwood hedges, and filled with a wide variety of flowers.

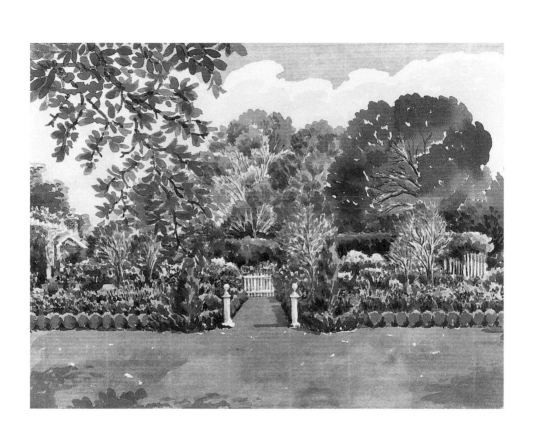

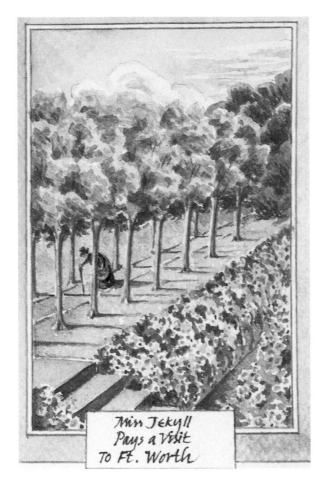

Miss Jekyll
Pays a Visit
To Ft. Worth

Anne Bass's wonderfully tailored rose garden in Fort Worth, Texas, is the adjunct to her rigorously modern Paul Rudolf house. In this picture Mark has added the stooped, anachronistic figure of famed English garden designer Gertrude Jekyll, who lived from the mid-nineteenth century to 1932 and has been an enormous influence on gardening. But would she get this contemporary look?

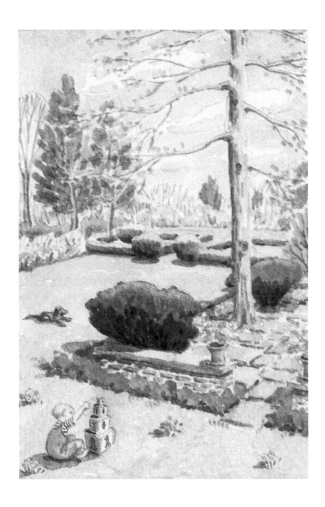

My godson Hugo Stenbeck is depicted here as a one-year-old engaged in time-honored play in the beautiful garden of his house in Locust Valley. It's early spring—the trees are just leafing out and little clumps of crocuses dot the lawn.

The courtyard of Samuel Reed's charming house in Hobe Sound, Florida, is an example of a skillful blending of nature, geometry, and art that creates a formality that is a pleasing contrast to the abundant tropical foliage. Its owner was reminded on cold winter days of what awaited him in the south.

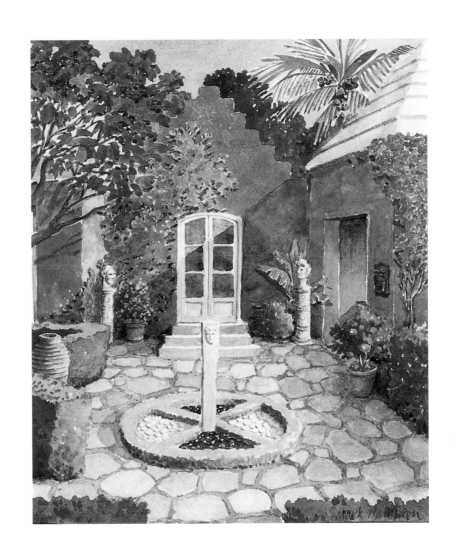

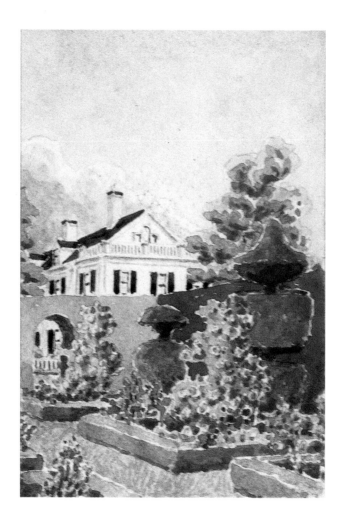

This is a fantasy view of a topiary and rose garden surrounded by high privet hedges that have grown up to overwhelm the once rather simple farmhouse we see peeking over the hedge. Mark was sure that as the house had grown, so would the garden.

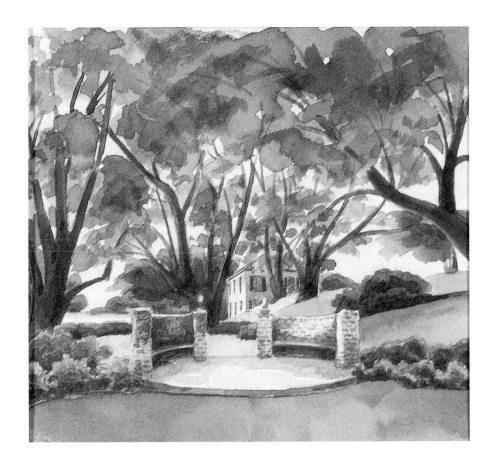

Live oaks and Spanish moss hang over these ivy-covered stone garden benches in South Carolina at Mulberry Plantation. Hundreds of camellias bloom in the winter, and in spring the azaleas take over. This little garden oasis and the rustic guesthouse behind it sit on the slope of a hill that faces vast watery rice fields and a river beyond.

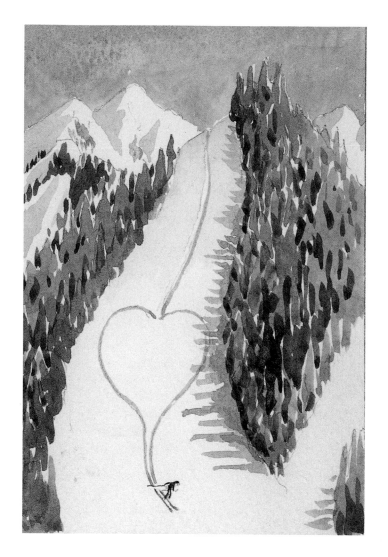

This was painted after a visit to Aspen. Our hostess's clever ploy of finding an incredibly handsome ski instructor was the only thing that coaxed me onto the slopes; with pen and brush, Mark won me back as his valentine.

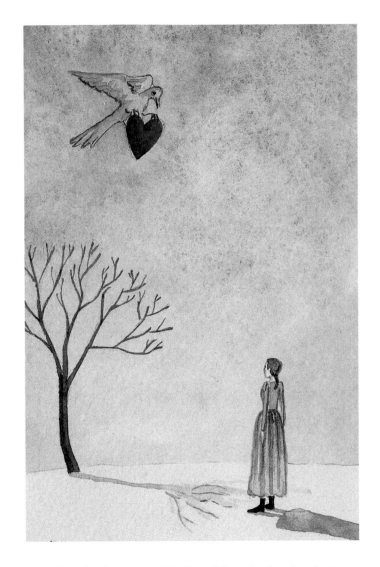

The year she played Abigail in *The Crucible* in high school, Kate received
this appropriate, if rather bleak, valentine.

A serene vision of me at lakeside in Switzerland in a dress I'd worn to a fabulous wedding there the summer before—an experience that Mark transformed into a valentine.

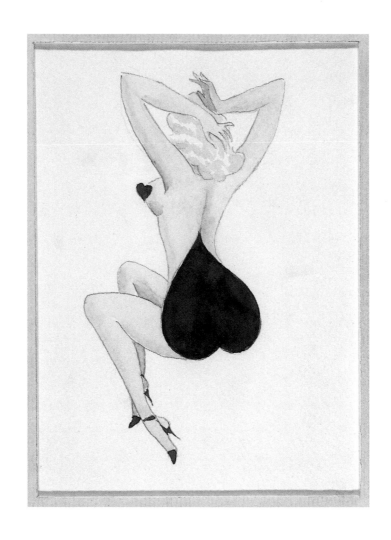

"My Fanny Valentine"

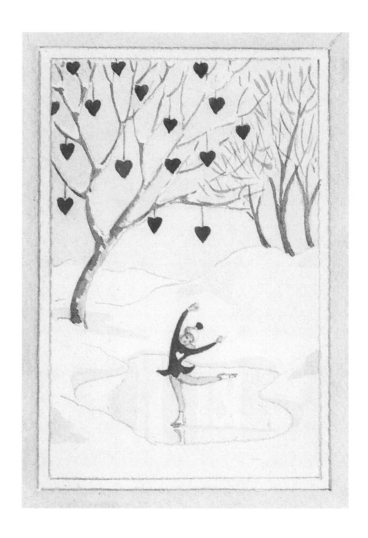

A valentine for Alexa when she was an ice-skating preteen spending countless freezing afternoons at the Sky Rink, New York City's equivalent to a frozen pond.

Alexa chose the theme of her valentine: Cinderella at the ball.

Thumbellina packing to leave the Mole's house was chosen by Kate.

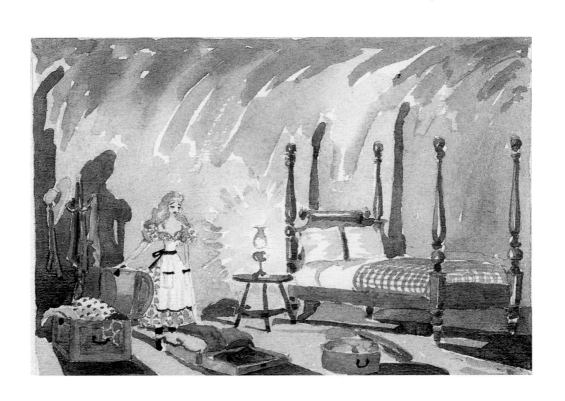

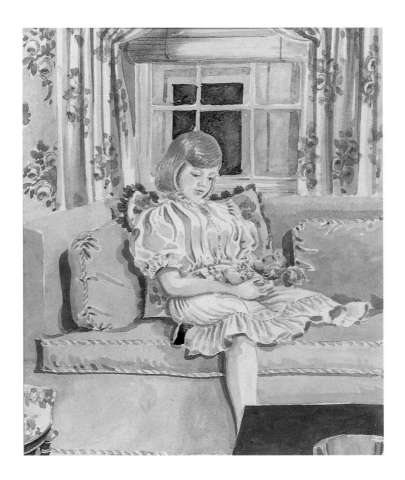

As a valentine for all of us, Mark painted our daughters in these pendant portraits that we cherish.

On the left, sitting on our living room sofa, is Alexa, age eight. On the right is Kate, age ten.

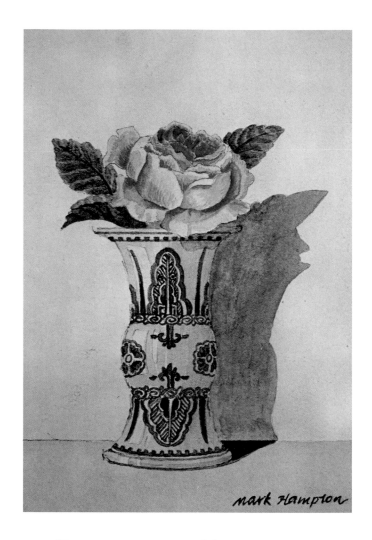

This rose in its Chinese vase was painted for me as an anniversary present twenty-five years ago, and has hung somewhere where I could see it in my daily life—whether city or country—ever since.

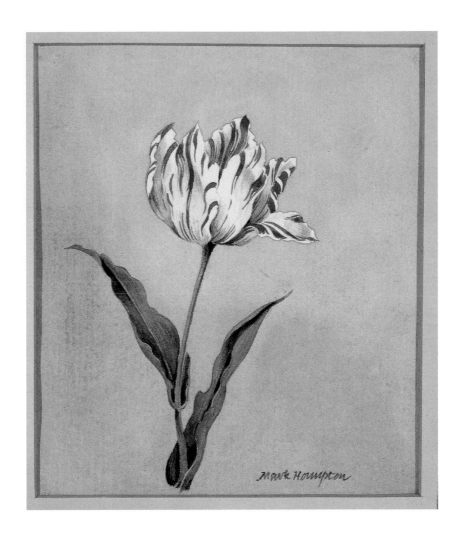

This beautiful tulip was painted for Lee Link, who is known for her gardening skill. Rendered in the rare specimen style of the eighteenth century, it seems to be a universal favorite among Mark's flower paintings.

Our friends Tom Pritchard and Billy Jarecki of Madderlake Flowers had just produced a book that included a fabulous photograph of nasturtiums. I raved so about it that Mark reproduced it in watercolor.

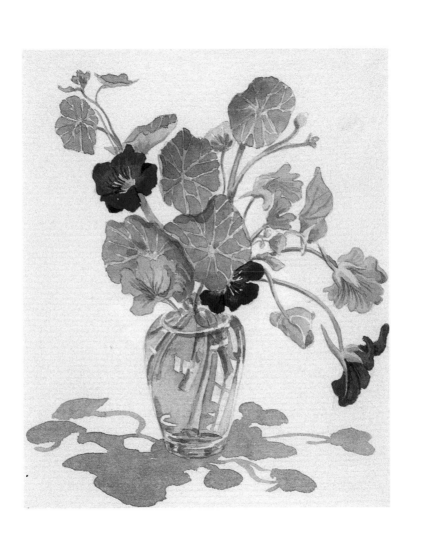

We were traveling when Mark realized it was soon to be Lyn Revson's birthday, so he put the pot of primroses in our hotel room on the windowsill and painted it with the building cornice in the background. It was mailed the next day.

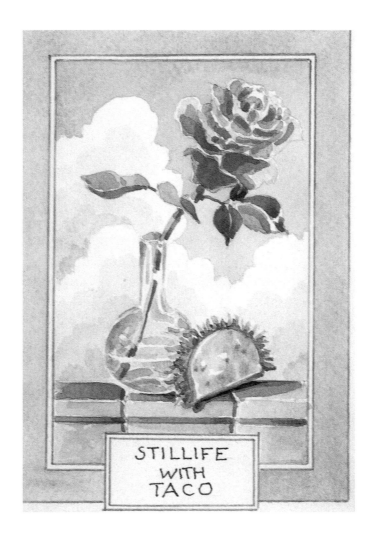

STILLIFE
WITH
TACO

Johnny Lou Davidson, Texas beauty queen, was the recipient of this tribute to her complexion and her taste buds.

This shiny Granny Smith was presented to our dear friend R. W. Apple (a.k.a. Johnny), chief correspondent for the Washington bureau of the *New York Times*. Mark did the illustrations for his excellent travel book, *Apple's Europe*.

This "perfect pair" was an anniversary present for Lee Radziwill and
Herbert Ross.

Shells are a passion of Louise Grunwald, who loves the sea, lives on its shore, and created a fabulous grotto room filled with shells.

Mark adored roses, and this vase of them atop a stack of books is one of the loveliest of his many rose watercolors. It was done for Anne Bass in the subtle, subdued colors she loves.

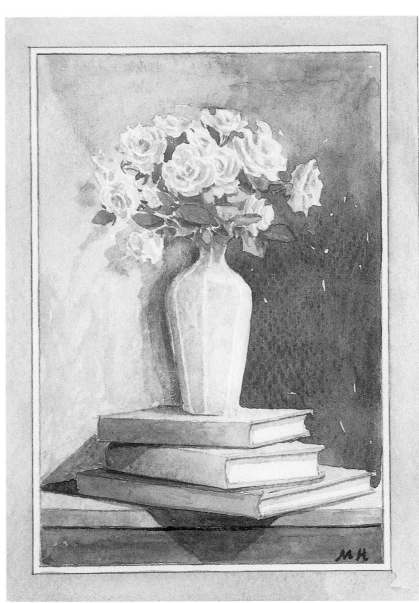

David and Nell Sawyer were thrilled at the arrival of their son Luke. When Mark was asked to be his godfather, he painted this christening card in the manner of Audubon.

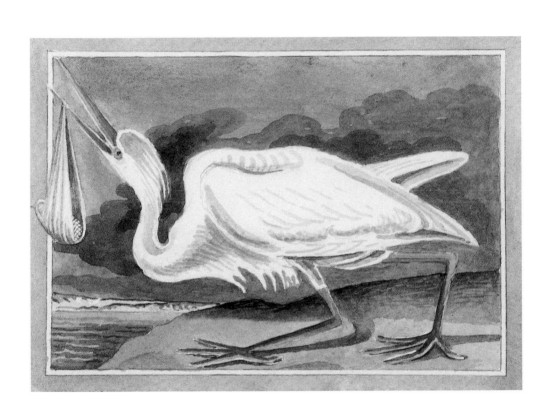

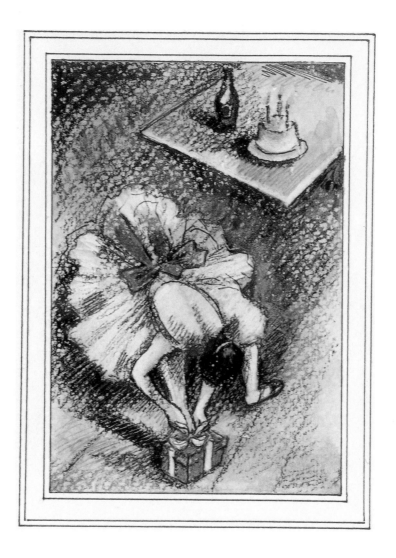

For balletomane and art patron Anne Bass, Mark painted his version of a Degas dancer; she is untying a birthday present instead of her shoe.

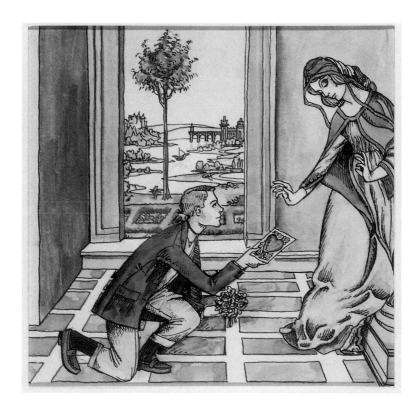

This valentine card was my very first experience with Mark's expertise as a watercolorist. We met in July of 1961, and, after numerous illustrated letters, *this* arrived at my snowed-under college dorm in February—I was overwhelmed! It's patterned after the Botticelli "Annunciation" at the Uffizi.

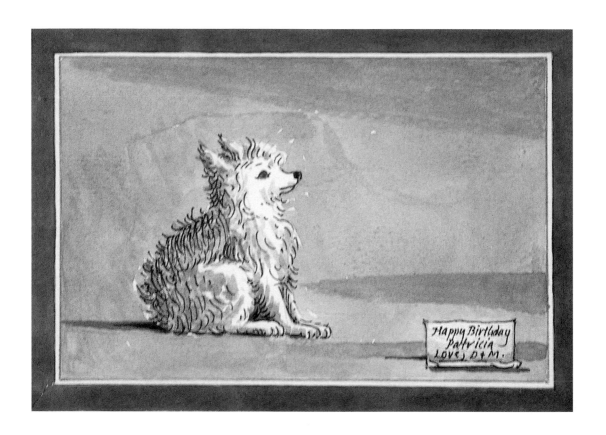

The dog in this watercolor, extracted from the famous Carpaccio of St. Jerome in his study, became a birthday card for Pattie Sullivan after a trip to Venice where we had all visited the Scuola di St. Georgio degli Schiavoni in which it hangs.

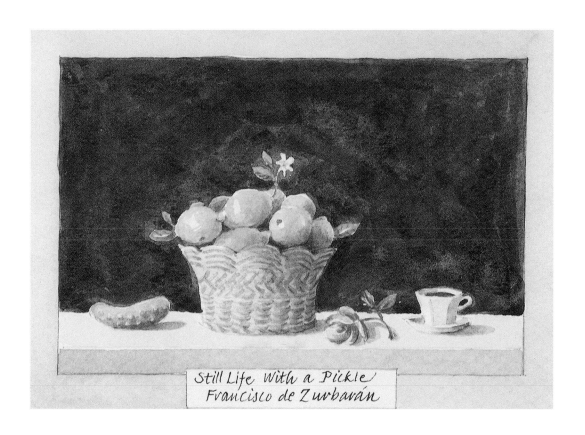

Still Life with a Pickle
Francisco de Zurbarán

This Zurbaránish anniversary card was painted by Mark for Jack and Teresa
Heinz, with a nod to their extensive collection of still lifes. It includes a
Heinz pickle, of course.

Painted for me one year was this mini Nike of Samothrace in watercolor. How flattering!

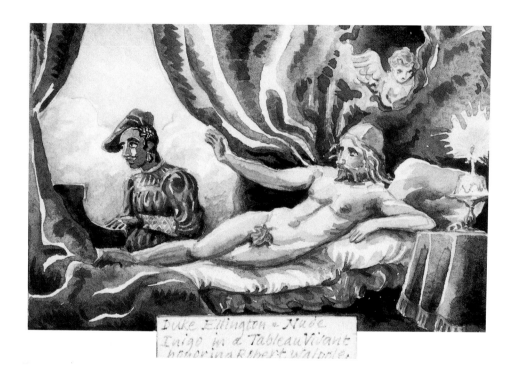

Carter Burden adored Inigo Jones, Duke Ellington, and Robert Walpole, so Mark threw them together in this homage to Manet/Goya/Velásquez, which he titled, "Duke Ellington and Nude Inigo in a tableau vivant honoring Robert Walpole."

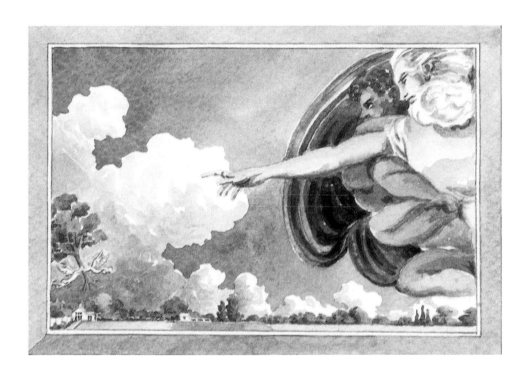

Blessings from Michelangelo's Sistine ceiling descend on a house on Long Island in the form of an allée of plane trees.

A Robert Kulicke oil sketch inspired this birthday card to me—and one candle was just enough!

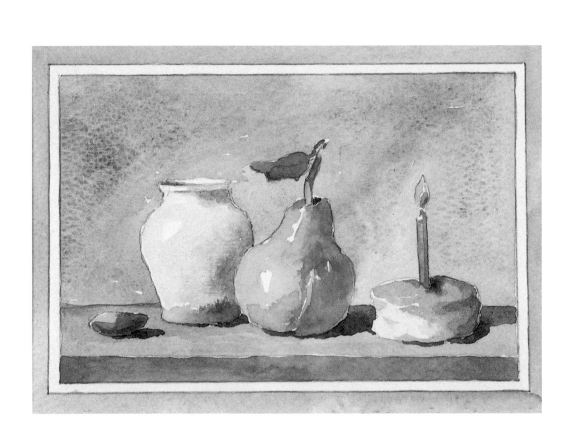

For our huntin', fishin', cigar smokin', and art lovin' friend Joe Hudson, Mark created this watercolor (signing it Oudry, one of Joe's favorite painters). Political correctness was obviously not a consideration.

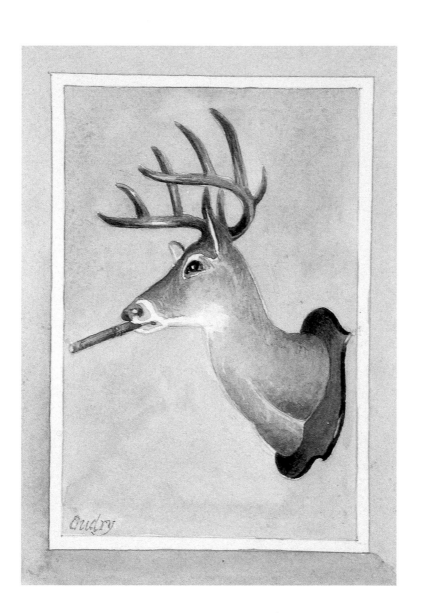

Oudry

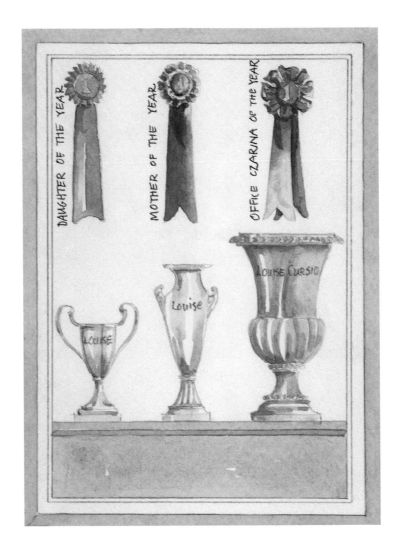

This card was painted for Louise Cursio, the czarina who really ran Mark's life at the office (and often, thankfully, beyond) with as much zeal as she could muster up after her devoted attention to her own family.

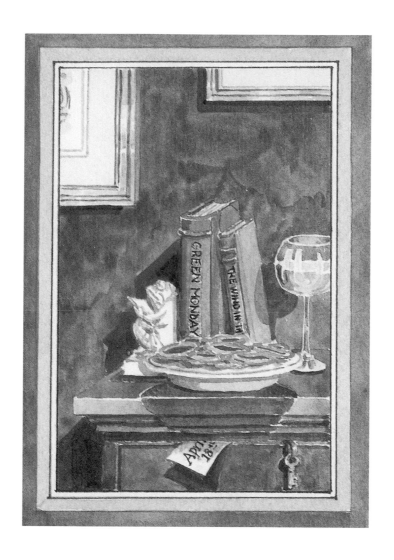

Some of his favorite things assembled for Michael Thomas in a birthday watercolor: *Wind in the Willows*, *Green Monday*, a Toad bookend, wine, and cookies.

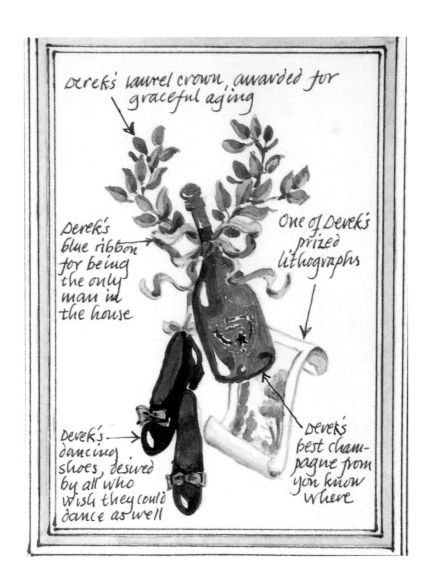

Painted for Derek Limbocker, this card says it all—and Derek *is* a fabulous dancer.

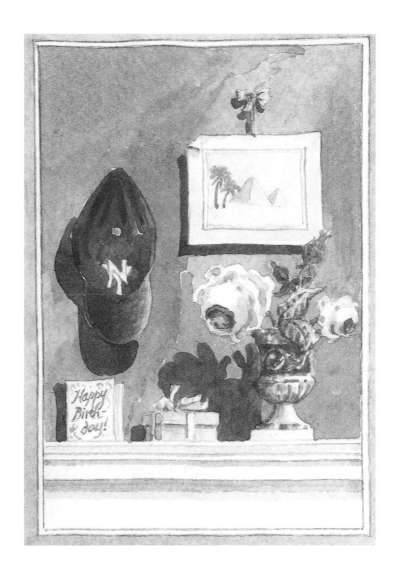

This assemblage was put together for a woman who adores Egypt, drawings, paintings, trompe l'oeil, flowers, porcelain, jewelry, and the Yankees.

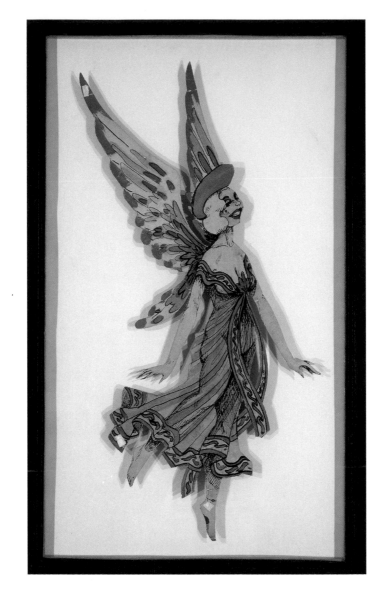

Sacred on one side and profane (or, at least, slightly naughty) on the other, this angel was painted on poster board about thirty-five years ago. Mark had just finished graduate school and was at his most art historical. For the most part, we kept her best side forward.

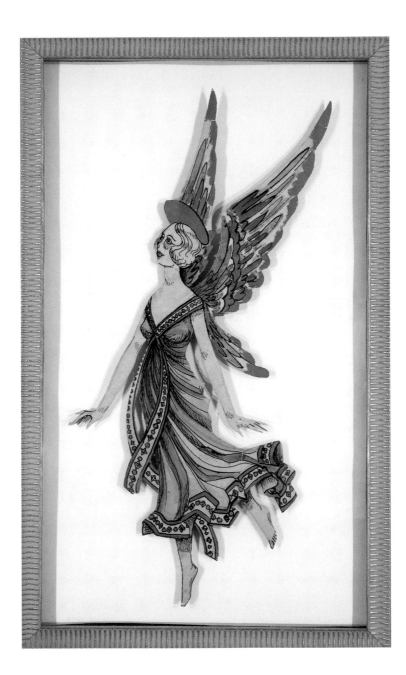

This is one of the Zipkin cards. Jerry's birthday was in December and he became irate—a frightening occurrence—if no watercolor turned up. Jerry had many, many cards.

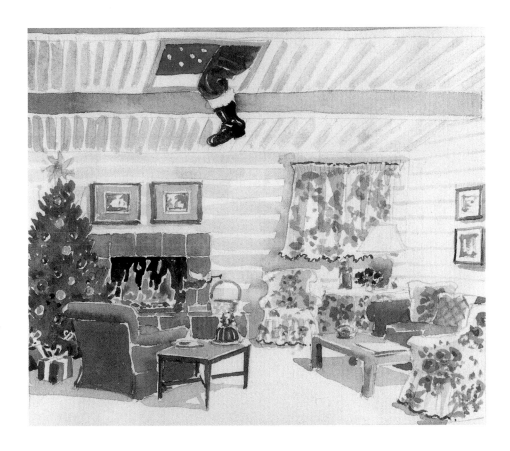

Mark's godchild Ian Tobin and his sister Alexis were spending Christmas in Colorado the year this was painted—Santa wisely chose the skylight alternative for his approach.

Michael Thomas was planning a trip to China the year he received this watercolor, one of the Toad series that Mark produced for him.

This was a Christmas present for newlyweds Teresa Heinz and John Kerry—to add a contemporary American note to their vast collection of Dutch and Flemish still lifes.

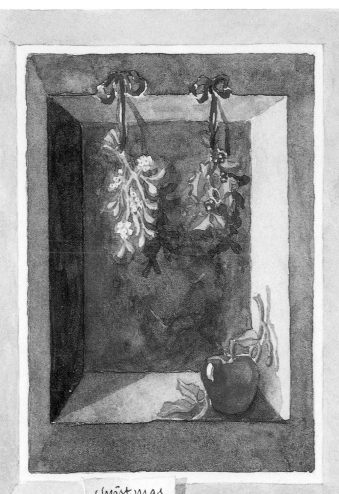

christmas
1996

Depicted here, on Santa Claus's lap, is Mr. Zipkin, bald spot and all. He was wonderfully acquisitive and always took an extra favor at parties, "for Mother." Mother had been dead for years.

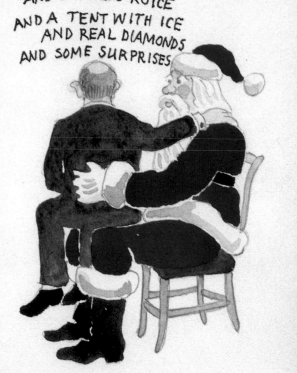

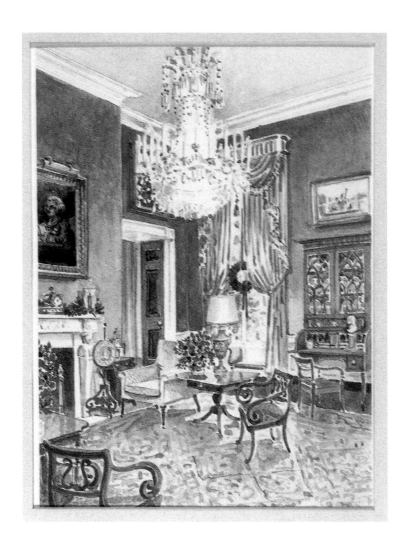

Mark did the official White House Christmas card twice; the first was in 1983 for the Reagans. It shows the Green Room decked out in holiday cheer.

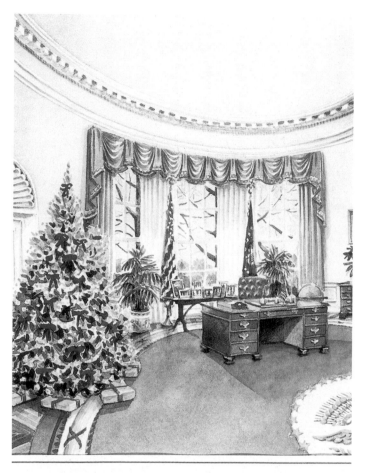

With our warmest wishes for a blessed Christmas
and a peaceful new year.

The President and Mrs. Bush

His second official White House Christmas card was done for George and Barbara Bush in 1990. The first version Mark painted had the Bushes' famous dog/author, Millie, curled up by the tree, which considerably cosied-up the scene but was deemed inappropriate to send to certain foreign dignitaries.

Entitled "A Brief History of July 11th," this trompe l'oeil card was created for our fourteenth wedding anniversary, which was also the seventeenth anniversary of our "first date" in Florence. We celebrated in July of 1980 by traveling to Yorkshire to visit country houses like Hardwick, Haddon, Chatsworth, and Castle Howard.

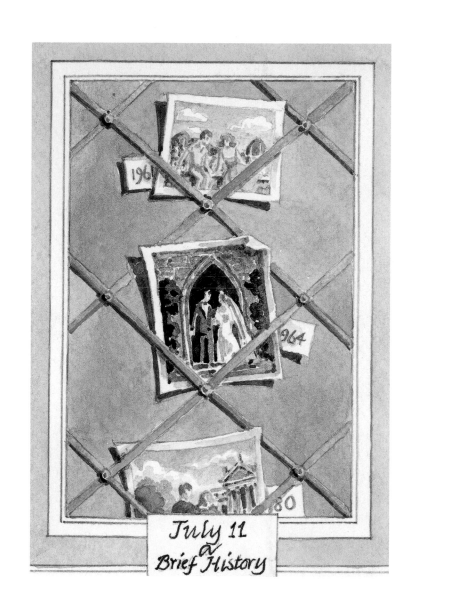

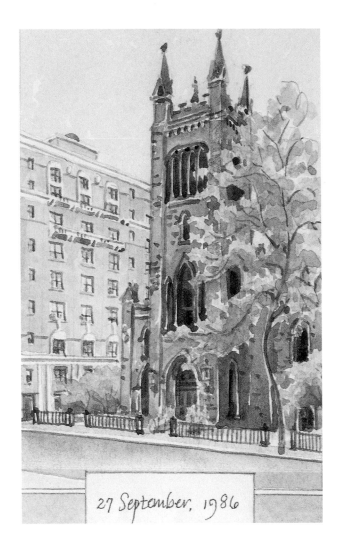

27 September, 1986

Mark painted this watercolor as a wedding present for Peter and Jill Melhado. Their wedding took place at the Church of the Ascension, Fifth Avenue and West Tenth Street, in 1986.

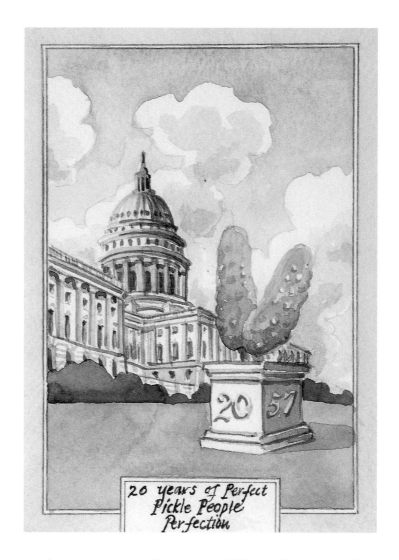

20 years of Perfect
Pickle People
Perfection

A twentieth anniversary card for Jack and Teresa Heinz cites them as "an example to us all" and places a statue of two Heinz pickles in front of the Capitol (he was then senator from Pennsylvania).

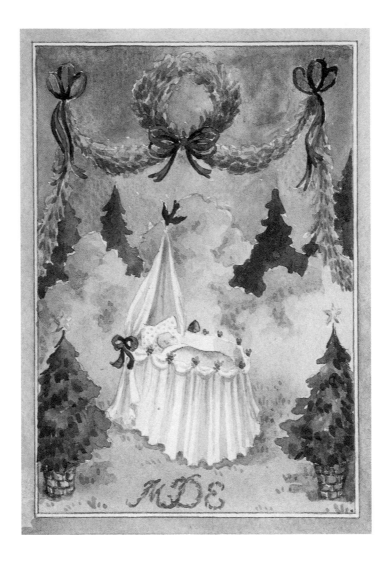

This is a christening card for Missy Davidson, whose arrival was the perfect Christmas present for her parents.

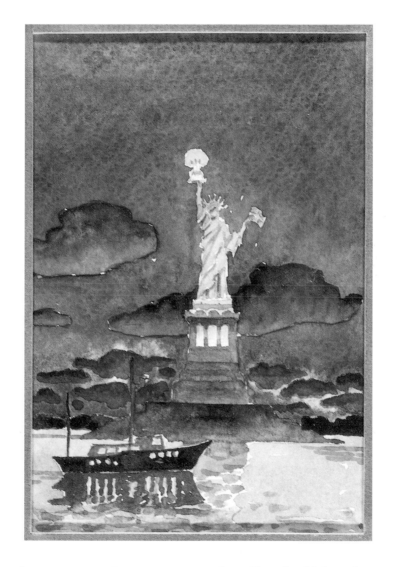

This nighttime watercolor commemorated our Fourth of July sail, on a boat called the *Black Knight*, to see the fireworks in New York Harbor.

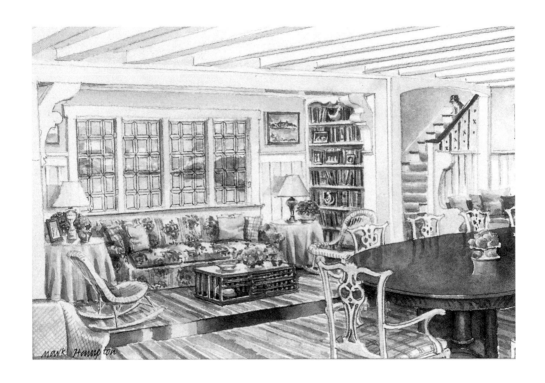

This cosy, family-oriented room in the Bushes' house in Kennebunkport, Maine, was decorated by Mark while President George Bush was in office. The house sits out on a peninsula in the Atlantic, and shortly after this room was finished much of it ended up *in* the Atlantic. Luckily, it has been replaced.

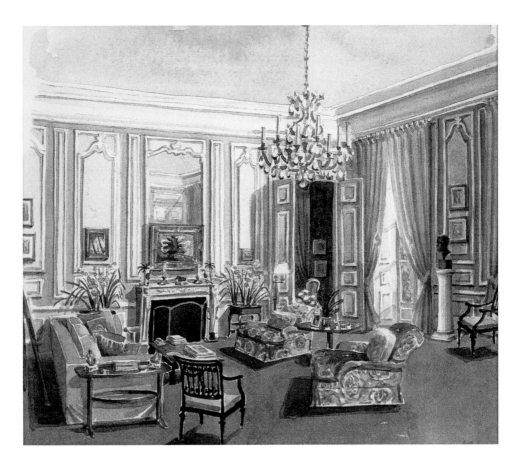

Mark decorated the private rooms for Pamela Harriman in the residence on the Faubourg St. Honoré in Paris when she was U.S. ambassador to France, and then he painted this watercolor of the sitting room for her. Through the door on the right are various small rooms, a library, and a large bedroom overlooking the garden. The famous photographer Diana Walker sent us a picture of Pamela placing Mark's picture front and center on the mantel in this room.

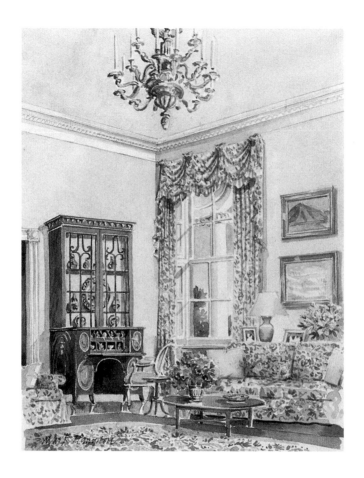

The private quarters in the White House are the province of each new President and First Lady to decorate as they wish. The Bushes asked Mark to help with this sitting room, their bedroom, the treaty room (which became the president's office upstairs), and the Oval Office. Barbara Bush worked the needlepoint rug that governed the color choices in this room.

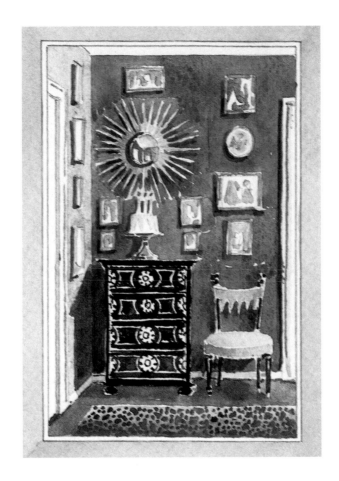

This is one of the many pictures our dear friend Albert Hadley has of Mark's interiors. Painted sometime in the eighties, it zeroes in on a corner of Albert's apartment in New York, displaying a charming grouping of furniture, objects, and pictures (and the inevitable birthday cake).

Both Joanne Stern, good friend and trustee of the Museum of Modern Art, and Mark loved the work of early modernist Eileen Gray, so Mark painted this homage as a present for her.

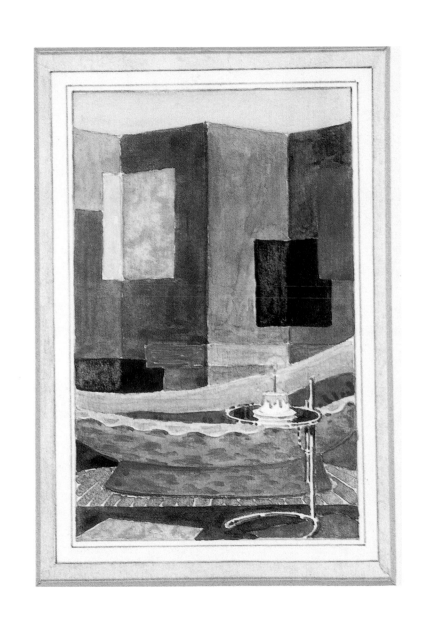

This watercolor was a specific request: Alton Peters wanted a unique present for his wife, Elizabeth, and came up with the idea of Mark's painting—from a photograph—the living room of the house she grew up in. Her parents were the Irving Berlins, and Mark was delighted to get to reproduce such a pretty and historic room.

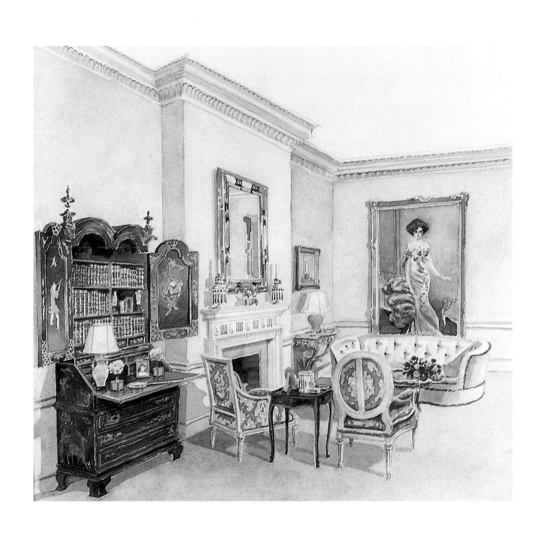

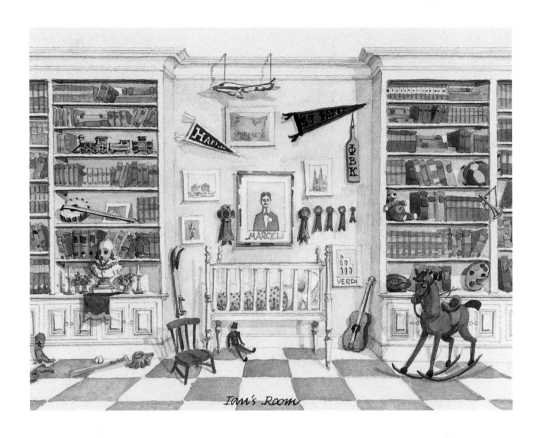

Ian's Room

The arrival of Leola and Robby Macdonald's first child, Ian, drove Mark into a frenzy of creativity—trying to imagine all his parents would want him to be and know. Proust and Shakespeare are there, along with bats and balls, musical instruments, trains, trucks, and lots of books and blue ribbons. Somehow Ian survived all this and is terrific!

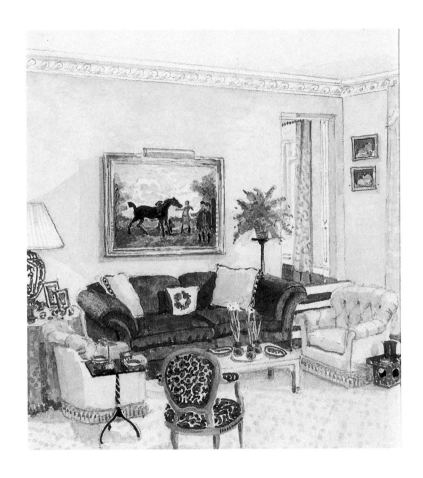

Louise and Freddy Melhado lived in a duplex maisonette in which they,
with the help of Parish Hadley, created the feeling of a small Irish house.
This was the living room with sunny yellow walls, a horse picture, and stairs
leading to another level.

Alexa had just decorated and moved into her own apartment in midtown Manhattan when she asked her father to paint this corner of her living room for her birthday.

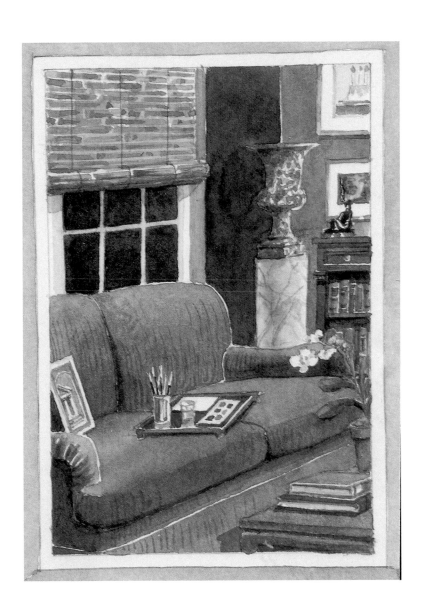

The living room at Holly Hill, Mrs. Vincent Astor's house in the country north of New York City, is comfortable, luxurious, and—thanks to floor-to-ceiling windows—always light filled. It's often people filled, too, because Mrs. Astor loves to entertain and believes in a lively mix.

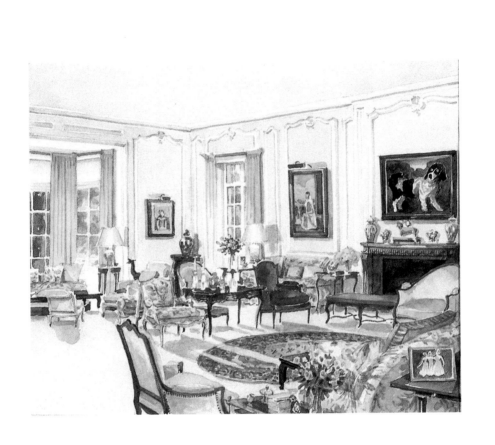

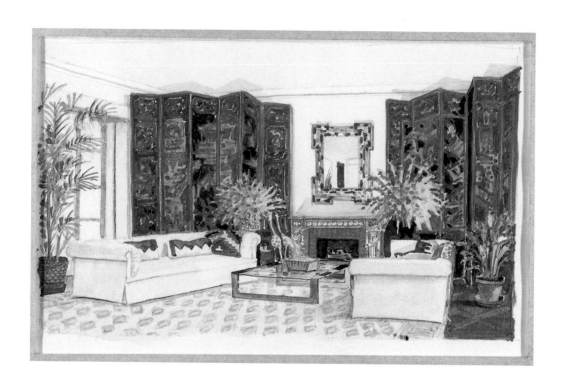

For Annette de la Renta, Mark painted the chic, luxurious, but still under-stated living room of the apartment she and her former husband, Samuel Reed, once owned.

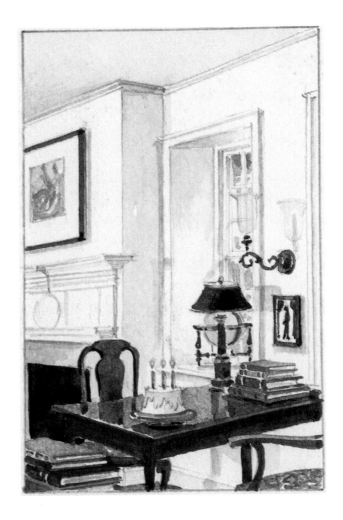

Bill Blass lives in classic simplicity, whether in city or country. This water-color is only a partial view of his country living room, but the spare, clean look and feeling come through. Bill keeps editing and moving things, so there are always fresh surprises.

This watercolor for Scalamandre depicts a charming provincial bedroom with walls, curtains, and bed hangings done in a single material accented by the use of a second pattern on the upholstered chair, stool, and throw pillow—all very Mark.

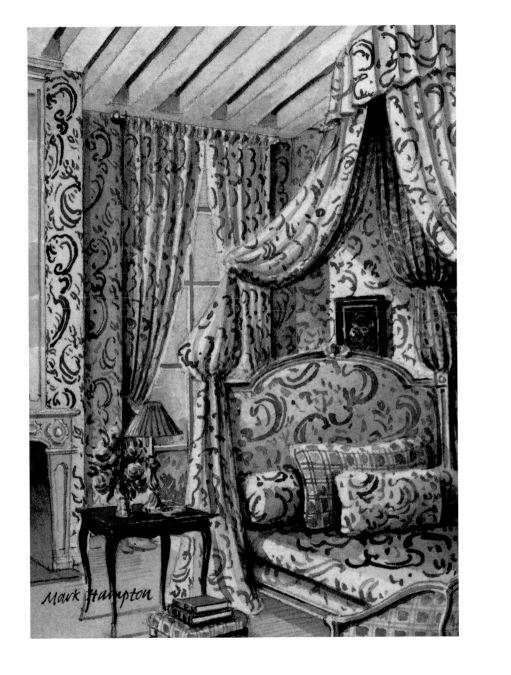

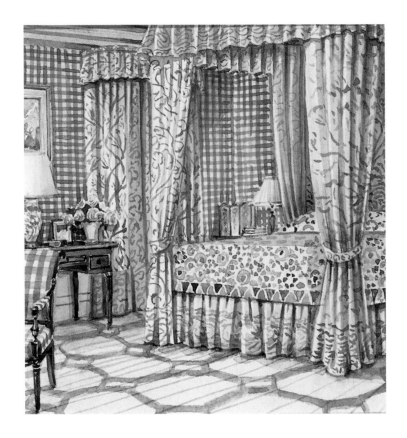

Lee Radziwill's bedroom in England was decorated by Renzo Mongiardino in one color with a lively mix of patterns and texture.

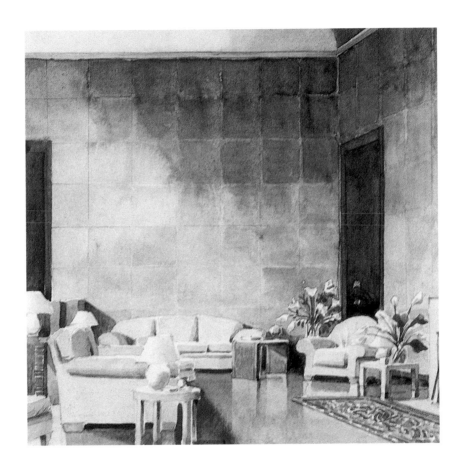

This fabulous Jean-Michel Franck room was done for the duc and duchesse de Noailles almost seventy years ago!

This watercolor was done for Mrs. Sidney Legendre. It depicts a corner of her library looking out over her desk to the massive live oaks that surround the house, Medway Plantation, outside of Charleston, South Carolina.

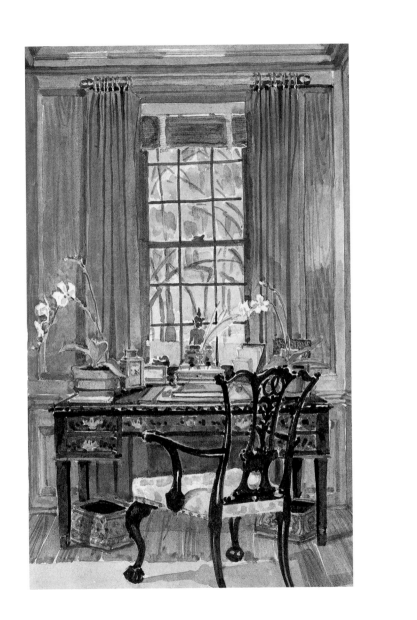

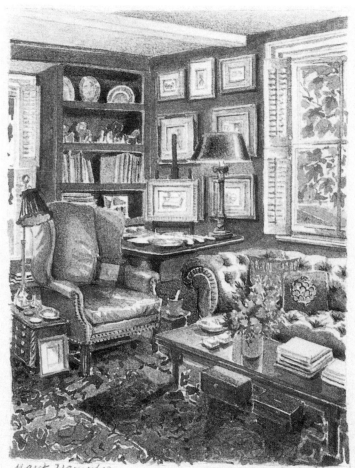

Mark Hampton for Henry & Audrey 1989

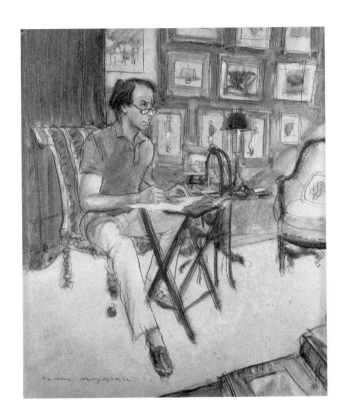

Mark sat for his Henry Koehler portrait while he was painting his own por-
trait of Henry and Audrey Koehler's Southampton living room (on left).

ACKNOWLEDGMENTS

The author would like to thank all of the owners of the watercolors collected here, as well as those that we did not have room to include, for sending their paintings to us and allowing them to be photographed, cataloged, hung in the several exhibitions that followed Mark's death, and included in this book. I am grateful to Pamela Fiori of *Town and Country* magazine, who sponsored the tribute to Mark at the 1999 Winter Antiques Show, and to Arie Kopelman, its chairman, who found space for it.

I would also like to express my heartfelt appreciation to those who have spoken or written kind words about Mark, as well as those of you who have written to me personally with your thoughts on Mark's character, life, and work. There is no measure to gauge what your words have meant to me. Thinking about what you have said has made the job of putting this book together immeasurably easier.

My gratitude to the New York School of Interior Design, especially its president, Inge Heckel, knows no bounds. She, along with Josh Link, who cataloged the paintings, Chris Spinelli, who photographed them, and the students who actually put them up on the walls, created an exciting show and an archive of Mark's work. The archive is a work in progress, so if any reader has one or more of Mark's watercolors that haven't been photographed, please let me know.

Special thanks are due to Bruce Stark and Bobby Rivera for assistance during several computer crises—and always to Mark Hampton, Inc., for support of all kinds.

And I offer my sincerest appreciation to my agent, William Clark, and to Joseph Montebello and my editors at HarperCollins for their belief that whimsy still has a place among the e-books.